ONE

ONE

Sons & Daughters

PHOTOGRAPHS *by* Edward Mapplethorpe

POEM *by* Patti Smith
FOREWORD *by* Edward Mapplethorpe
INTRODUCTION *by* Samantha Boardman, M.D.
ESSAYS *by* Andrew Solomon, Francine Prose,
Adam Gopnik, Susan Orlean

 powerHouse Books Brooklyn, NY

One year one life
One coupling vine
Hands like yours
Eyes like mine
A shard of love
A troubled brow
An ancient soul
We know not how
Bathed in a light
Of cherub wings
A sense that one
Divines all things
One year one life
One girl one boy
One will churn
Reclaim our joy
One will build
One will play
Notes that none
Would cast away
One is beauty
One is truth
One is future
One was you

— patti smith

for
Harrison Chen-Siang Mapplethorpe
Sunday, September 14, 2014; 8:22pm

FOREWORD

COMING *of* AGE

One: Sons and Daughters commemorates a project that began twenty years ago when, in 1995, I took my first commissioned portrait of a baby girl who just turned one year of age. During the editorial process of selecting the image I discovered something quite remarkable—the photograph wasn't a baby picture at all, but rather a revealing portrait of a person who happened to have just turned one. The experience was so compelling, since that first portrait I have gone on to photograph well over one hundred children on the occasion of their first birthday.

The act of photographing these children is a very humbling experience. The situation demands that I immediately gain the trust of these little strangers, which allows me the rare privilege of sharing their inner lives through the photographs. Who are these children that sit before me? What have they already discovered about life in the short period of twelve months? What are they thinking as a flash of light illuminates them? Who will they become?

Most people can reminisce with old family photographs and be delighted to discover in hindsight how revealing a picture can be of its subject. I, on the other hand, have the unique opportunity of documenting these children at a seminal moment in their lives, hoping to capture a glimpse of who they might become. At this age humans have developed an individual personality that will serve as their foundation for future experiences, yet they have not been marked by the pressures and conventions that society imposes. It is extremely rewarding to present the final portrait to the parents and to observe their wonder at the formed person peering back at them. It often happens that I hear years later how a particular photograph presciently captured a fundamental aspect of that child's personality.

Twenty years after the first portrait, I now find myself with a one-year-old son. This life-changing experience, coinciding with the "coming of age" of my first sitter on the occasion of her twenty-first birthday, bookends the beginning and end of childhood and innocence. This publication celebrates the first birthday as a pivotal milestone in life's journey and the hope and promise of what is to come. The emotions conveyed through the myriad expressions presented here reflect universal experiences that transcend class, gender, race, and nationality. With this in mind, each photograph is merely titled with the child's date and time of birth to underscore our common humanity.

— Edward Mapplethorpe

INTRODUCTION

ON *the* BRINK

Babies are born curious. The entire industry of baby-proofing is built on this fundamental human instinct. As their senses and abilities develop, their sense of wonder expands too. Undaunted by fear, they venture into the unknown with great interest and an unbridled desire to know and understand more.

We hear a lot about the "terrible twos." People forget to tell us about the "wild and wiggly ones." By the age of one, children are determined, unstoppable little warriors. I vividly remember my daughter's favorite words, "do by self" whenever I tried to help her put on shoes or stand up. "No" and "mine" were other favorites.

Like other children her age, she had a will of her own. You could see it in her eyes. That look is what I love so much about Edward Mapplethorpe's photographs. They so perfectly capture these little beings on the brink of personhood, bursting with energy and an insatiable craving to discover the world around them.

Their curiosity is palpable. Everything is new and interesting to a one-year-old child, their little bodies and minds yearning to break free and explore. The tranquility of the photographs is an illusion—it is a micro-moment of stillness before the child wiggles out of the special chair holding them upright.

What happens to this raw curiosity? At what age do we un-learn and decide to play it safe? One cannot look at these photographs and not wonder what it feels like to be curious without fear. They remind us to keep an open mind, to challenge received notions of truth, and to rethink what we think we know.

Asking questions lies at the heart of cultivating curiosity:

Preschool children, on average, ask their parents about 100 questions a day. Why, why, why— sometimes parents just wish it'd stop. Tragically, it does stop. By middle school they've pretty much stopped asking. It's no coincidence that this same time is when student motivation and engagement plummet. They didn't stop asking questions because they lost interest: it's the other way around. They lost interest because they stopped asking questions.[1]

Indeed, children are often the best teachers we have. According to Harvard psychiatrist George Vaillant, how we answer the question, "What did you learn from your children?" predicts how well someone will age. Some parents believe children should absorb their wisdom like obedient sponges. For these parents, the thought of learning anything from a child is preposterous. In comparison, the belief that one can learn a great deal from children reflects an openness to change. It is no surprise that these flexible thinkers tend to age better. They don't get stuck in how the world used to be or should be.

We have a lot to learn from the wide-eyed one-year-olds depicted in these photographs. They are experts in curiosity, creativity, and wonder. Thanks to Edward Mapplethorpe we have the privilege of basking in it.

— Samantha Boardman, M.D.

[1] Po Bronson and Ashley Merryman, "The Creativity Crisis," *Newsweek*, accessed July 10, 2010, http://www.newsweek.com/creativity-crisis-74665.

YOU WILL KNOW THEM
by THE LIGHT IN THEIR EYES

Human infants are born earlier, evolutionarily, than infants of any other species. The largeness of the human brain demands this; the baby has to come out before his or her head grows too massive for the birth canal. Lower mammals enter the world able to negotiate tough challenges; non-human primates are born with the ability to cling; but humans emerge without any redeeming competencies. Adults are moved by this puerile vulnerability. If the helplessness of infants didn't seduce us, the species wouldn't survive. One of parenthood's first satisfactions is lifting your newborn, hearing the crying abate, feeling the supernal calm seep from your own body into your child's, then beholding how a face so recently contorted with dismay now seems content with the world. At first, that is adequate satisfaction. Though we are told by experts that our child's future personality is manifest almost immediately, most of us (and indeed most of them) can't read those initial signs with much fluency. Our later recollection that we could see everything from day one is usually revisionary history, a romancing of parenthood. Only by degrees do we glimpse who this person is and will be.

There is increasing evidence that the experiences of an infant determine a great deal of his or her character and identity, that early nurture urgently complements originating nature. Attachment theory proposes that the primary caregiver's affective style will determine the child's understanding of the world as a place where he is seen and his needs are met, or, conversely, as a place where his anger and expressions of pain are fruitless. Rat mothers express care by licking their pups in their first few days of life. If you cross-foster female pups, those biologically born to a low-licking mother but put in the care of a high-licking one will grow up to be high-licking mothers themselves. Likewise, those born to a high-licking mother but placed with a low-licking one will grow up to be low-lickers. The fact that a newborn of any species cannot yet lay down explicit memory does not mean that such a being is immune to circumstance. Early experience is permanently inscribed in the brain's most fundamental circuitry. A child is continuously developing, and the fastest developing is the earliest.

Our initial love for our children can look irrational. Newborns seem nearly interchangeable, and our first attachment to them is based largely on an abstract feeling of ownership. It is an anticipatory, tautological love: we love them because they are our children; we know they are our children because we love them; and we require no more reason than that. As they grow, however, our love comes to be based on who they are. We embrace them not only because they are ours, but also because they are funny, or sweet-natured, or intelligent, or easy, or brave, or because they seem to love us. We tell each other representative anecdotes to corroborate their uniqueness, but what is particular in them cannot be reduced to such contained narratives. An attuned caregiver sees the specificity of his or her child long before an outsider can but must work to convey that recognition to others. The world gains access to a child only by slow degrees.

This transition to knowability is gradual, but it reaches an initial efflorescence when the child is about a year old, by which time adults really can read some of who he or she will be; a year of caretaking renders them legible. This is when what we know about them begins to upstage what we project onto them. The richer intimacy is usually welcome, but it is not easy. At a year old, children can express disappointment, anxiety, fearfulness, humiliation, sorrow. They can trust or mistrust, and they can have a peculiar sense of arbitrary hilarity. They are astonished and charmed by life, but they are also surprised and horrified. The sign of their dawning maturity is the meaning in their faces, the evidence that they know and think and feel more than they did before. We can't see their brains expanding daily, and they don't yet have words to tell us what's going on. Yet their faces embody their burgeoning inner lives.

The children in Edward Mapplethorpe's photographs are fully realized people caught just before language upstages the light in their eyes, their pouting mouths, their brows raised in dismay at an alien world. Though certain grey nuances between sentiments come with speech, the intensity of passion comes much sooner. These images of children express that force: this one seems so unhappy; that one seems oddly anxious; this one seems touchingly shy; and that one, alarmingly aggressive. Soon, the adult tension between what is said and what is communicated will begin to complicate things; this is the final moment of expressive innocence before that maturity sets in. Redolent with truth, these images seem to know everything that is knowable about their subjects.

The psychologist D.W. Winnicott wrote in 1947, "There is no such thing as a baby . . . if you set out to describe a baby, you will find you are describing a baby and someone." He meant simply to illustrate the extreme reliance of small children on proximate adults, but his words point to the complexity of dependence, to the uncertainty principle as it applies to people under permanent custodial observation. The unabashed countenances in these photographs implicitly represent not only the children who are their explicit subjects, but also the photographer and the parents. None of these children has the dulled look of neglect. Perhaps this shouldn't surprise; unloved children don't find their way to the photographer's studio so readily. But many children are loved unwisely; they are bundled into gingham smocks, arranged in flowerpots, then tickled or given candy to manifest implausible high spirits before the camera. The resultant images, pasted into albums or copied onto iPhones for display to social acquaintances, memorialize a fantasized version of childhood as a time of innocent bliss. The children in Edward Mapplethorpe's portraits, by contrast, are permitted to be transparently themselves; they look out at us in a state of adamantine, unrelenting humanity.

— Andrew Solomon

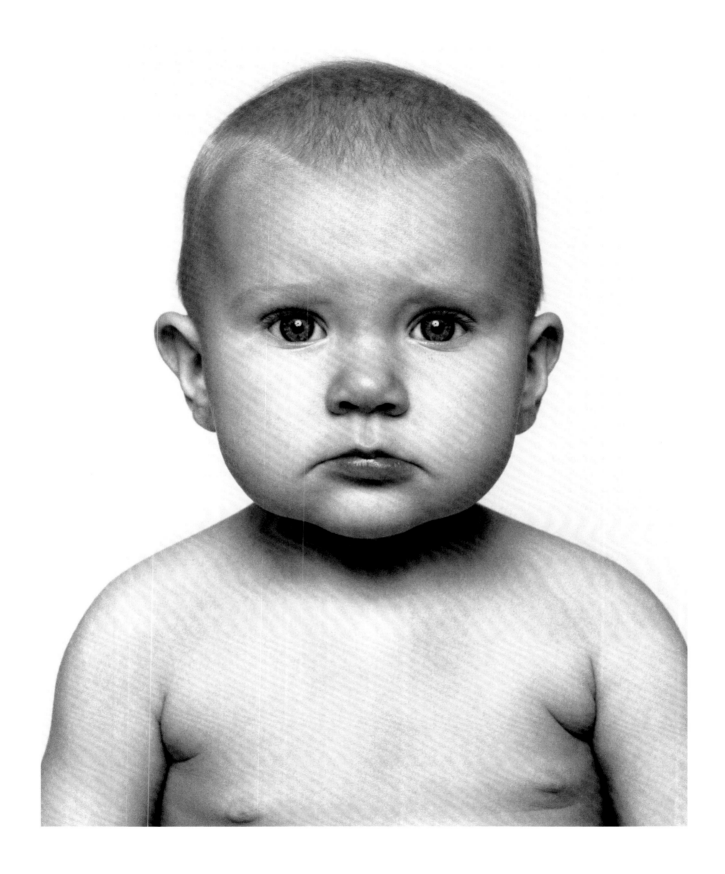

Monday, November 2, 2009; 2:42pm

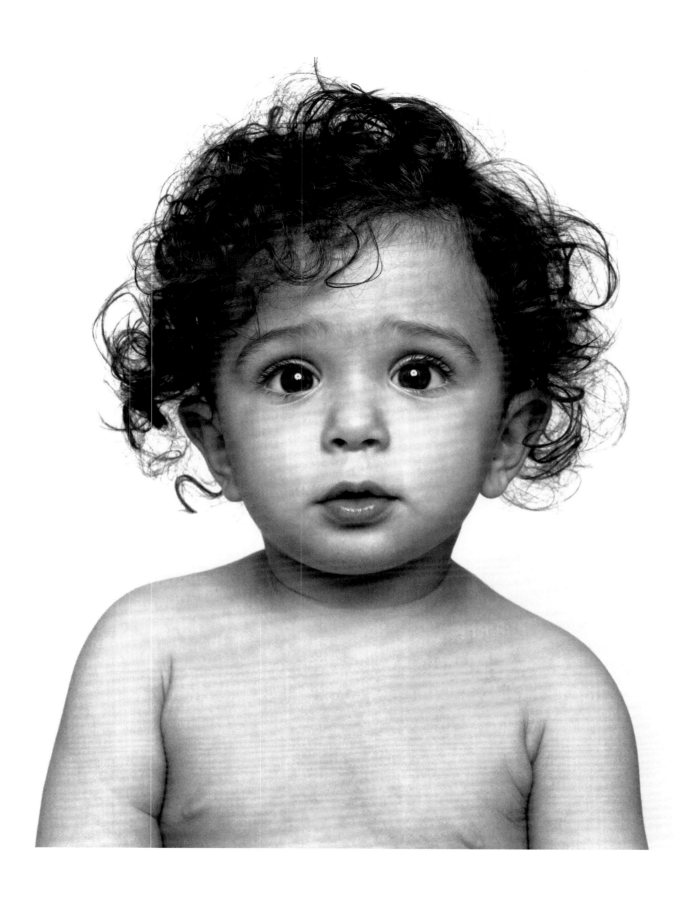

Friday, January 26, 2007; 3:44pm

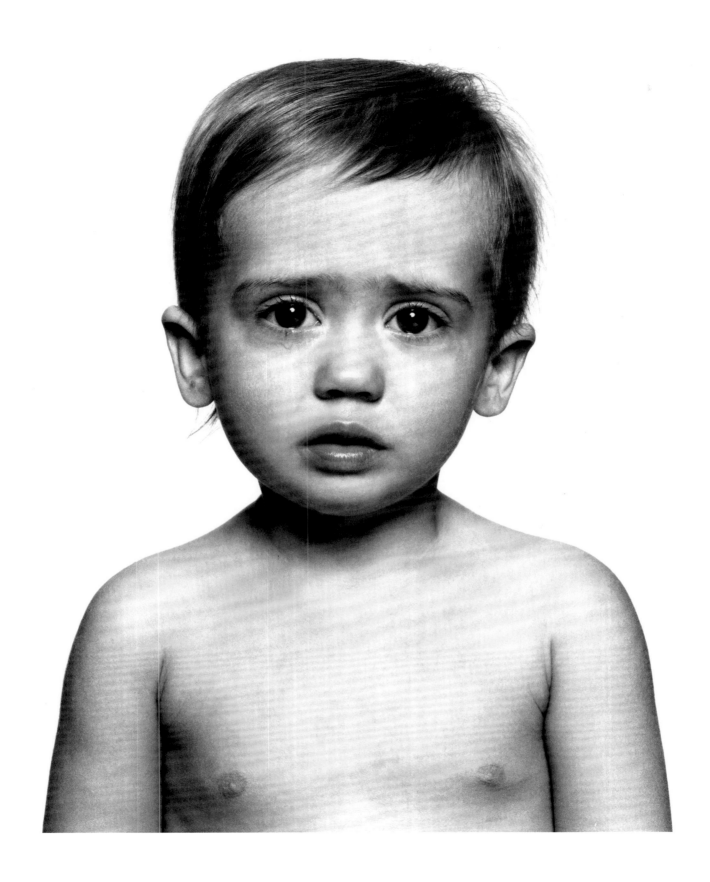

Wednesday, March 5, 2003; 9:31am

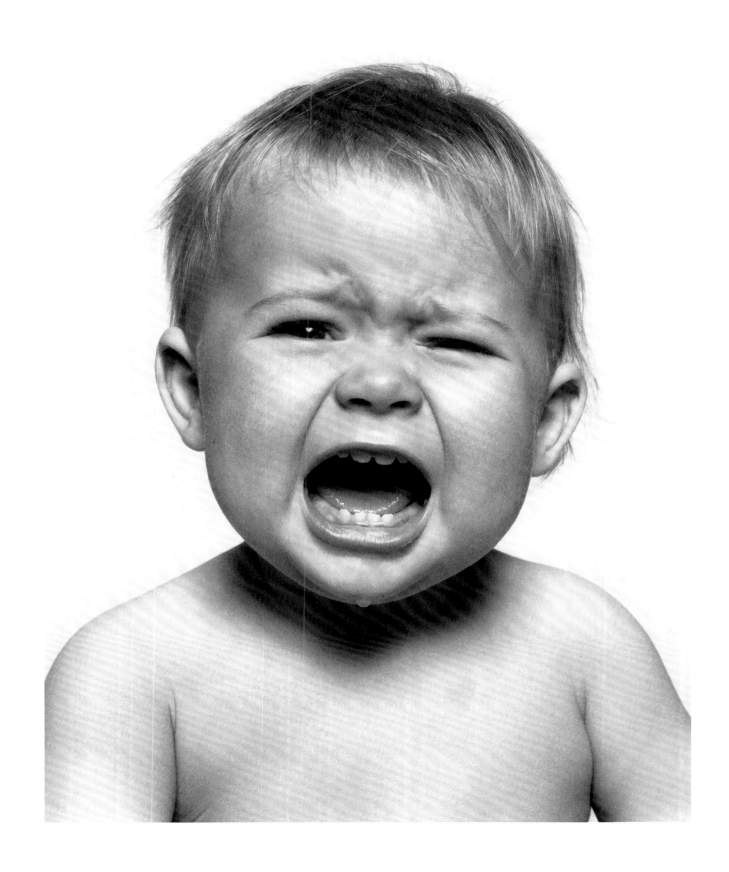

Saturday, December 25, 2010; 2:24am

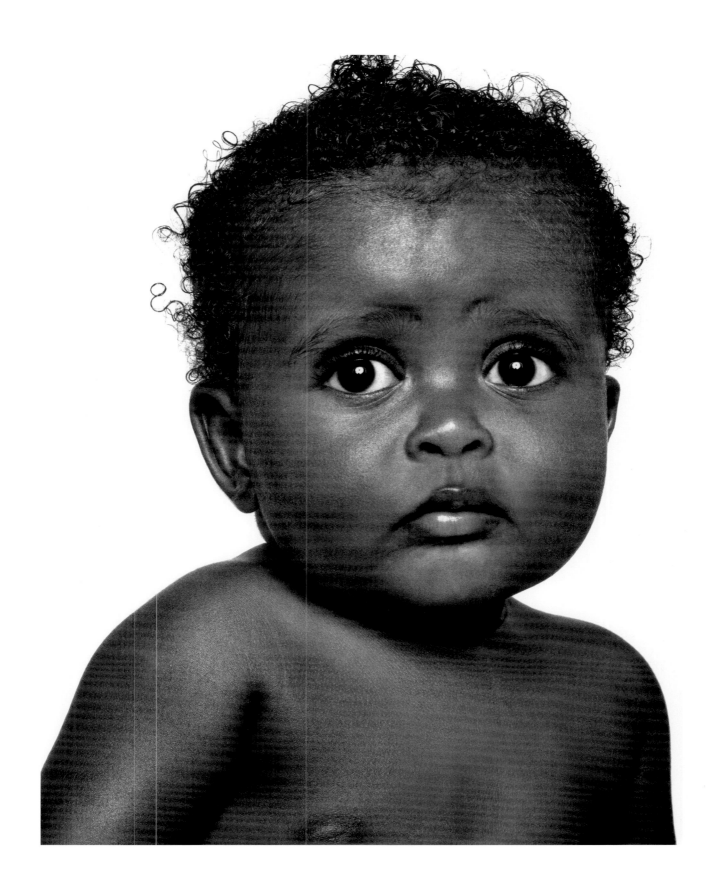

Saturday, October 13, 2012; 6:00am

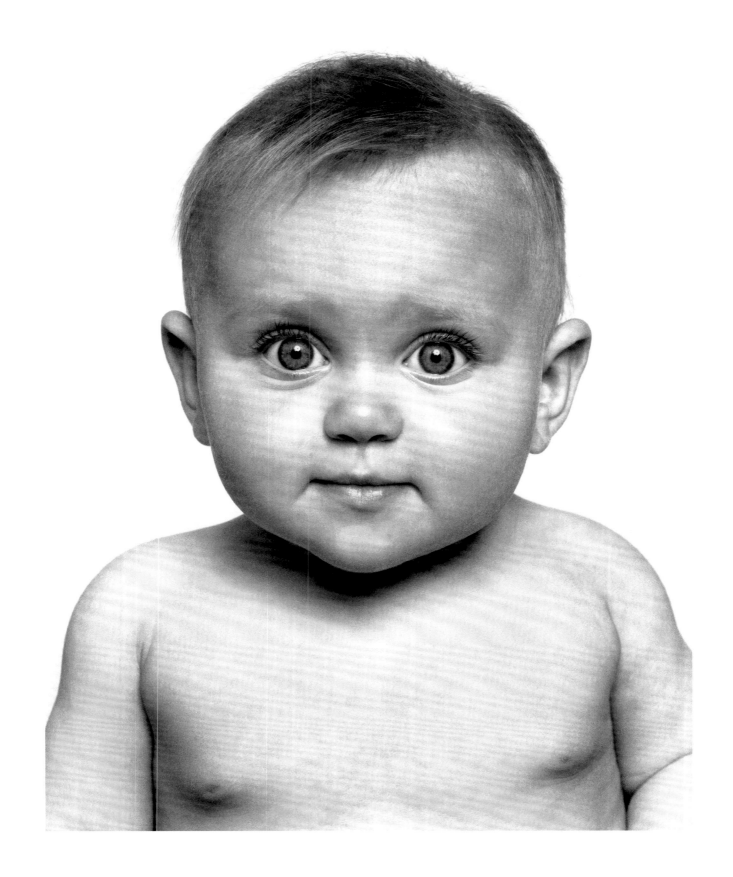

Thursday, September 9, 2004; 2:54am

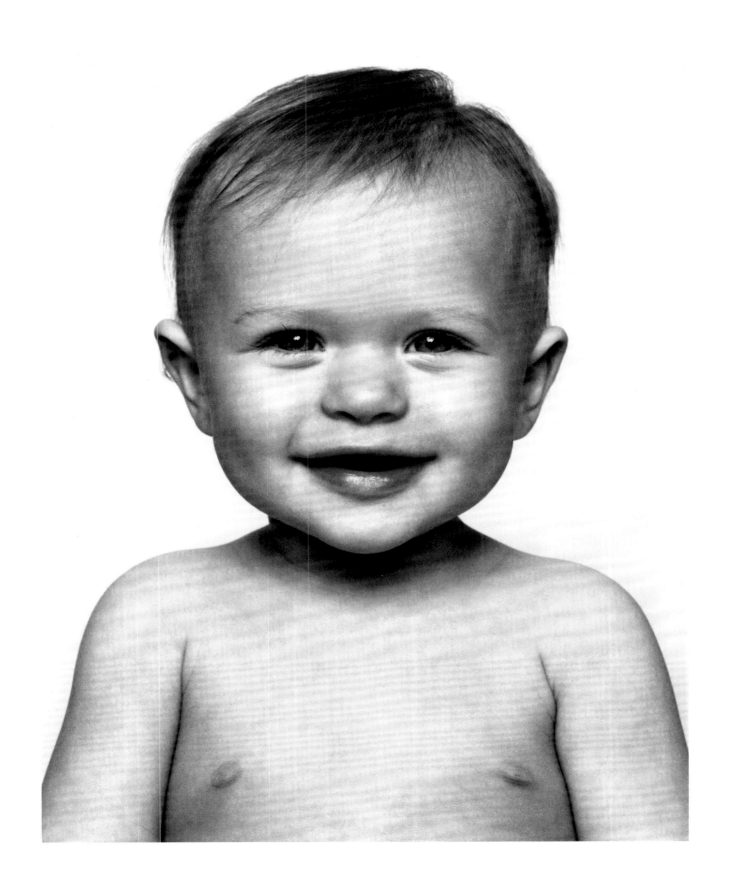

Sunday, May 17, 2009; 1:06am

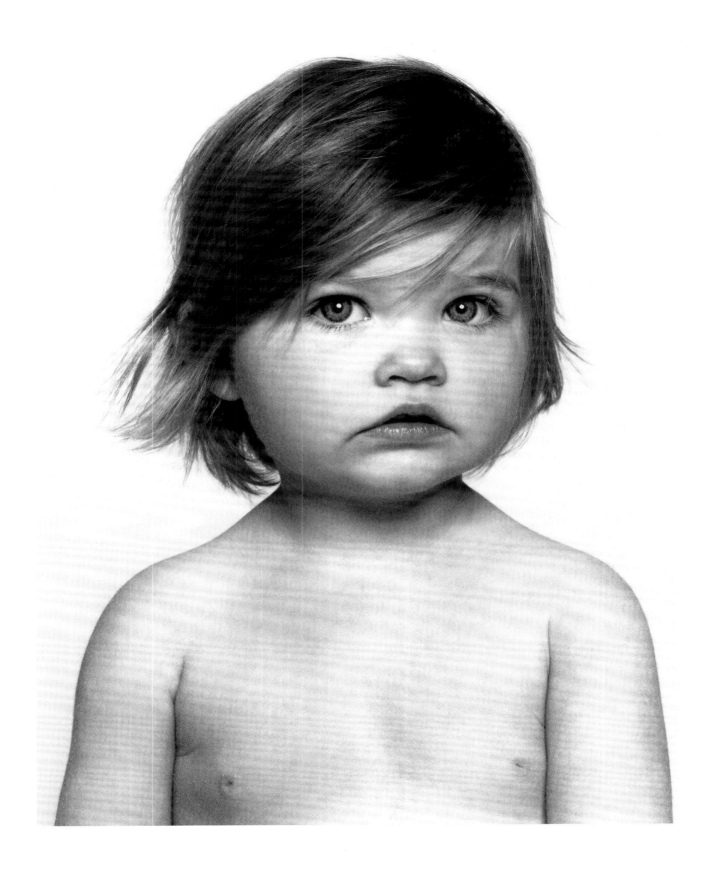

Tuesday, January 20, 2009; 7:10pm

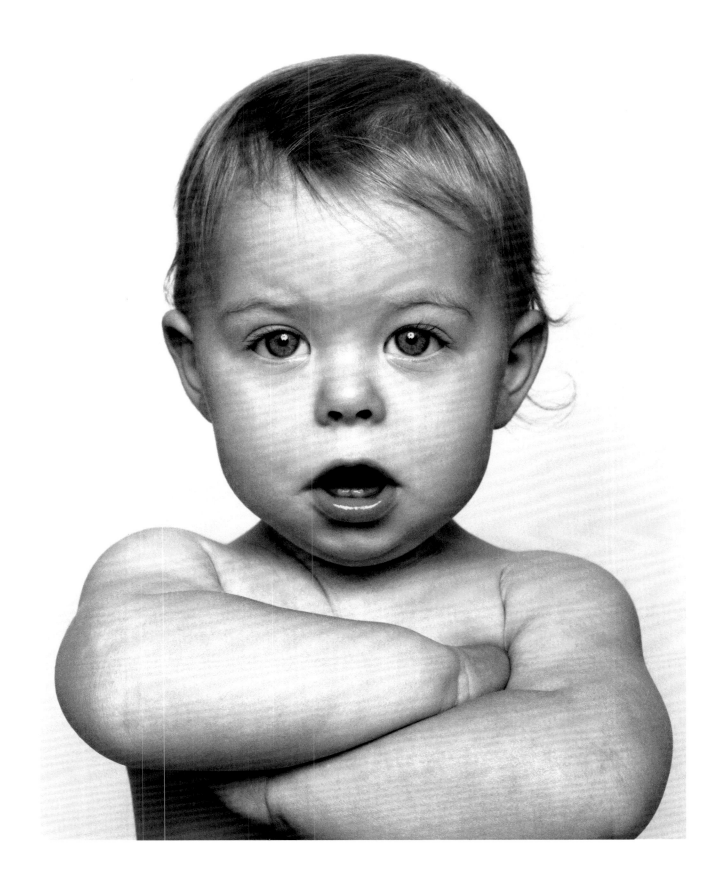

Monday, April 30, 2007; 12:35pm

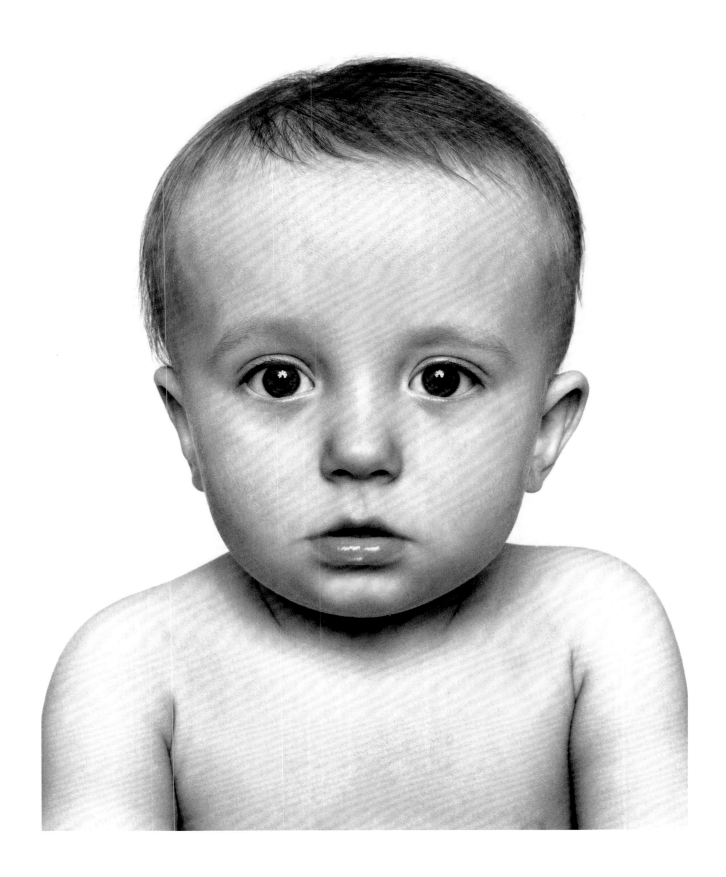

Friday, April 12, 2002; 10:30pm

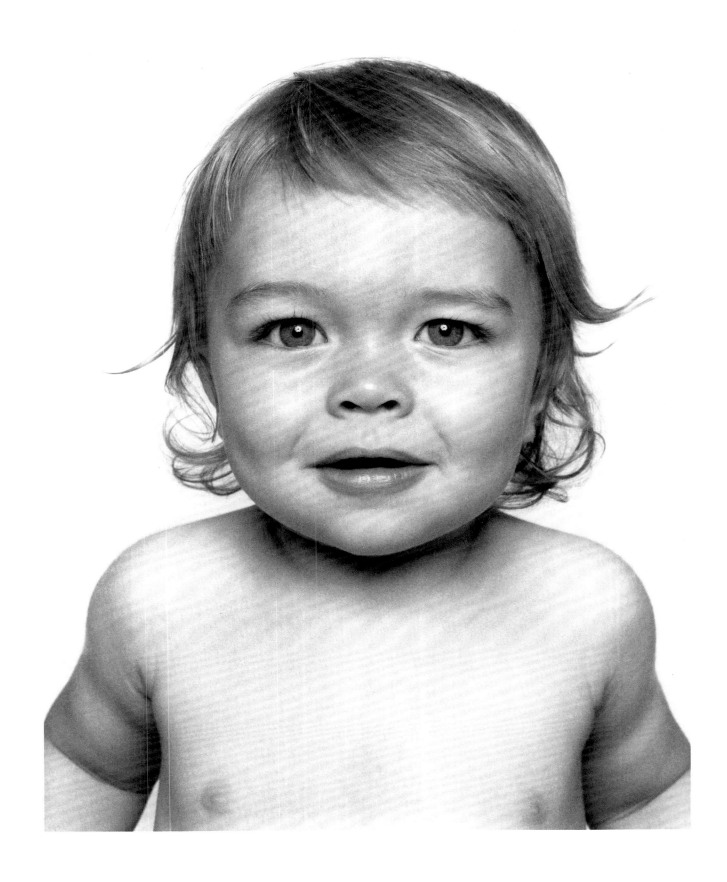

Thursday, June 30, 2011; 5:47pm

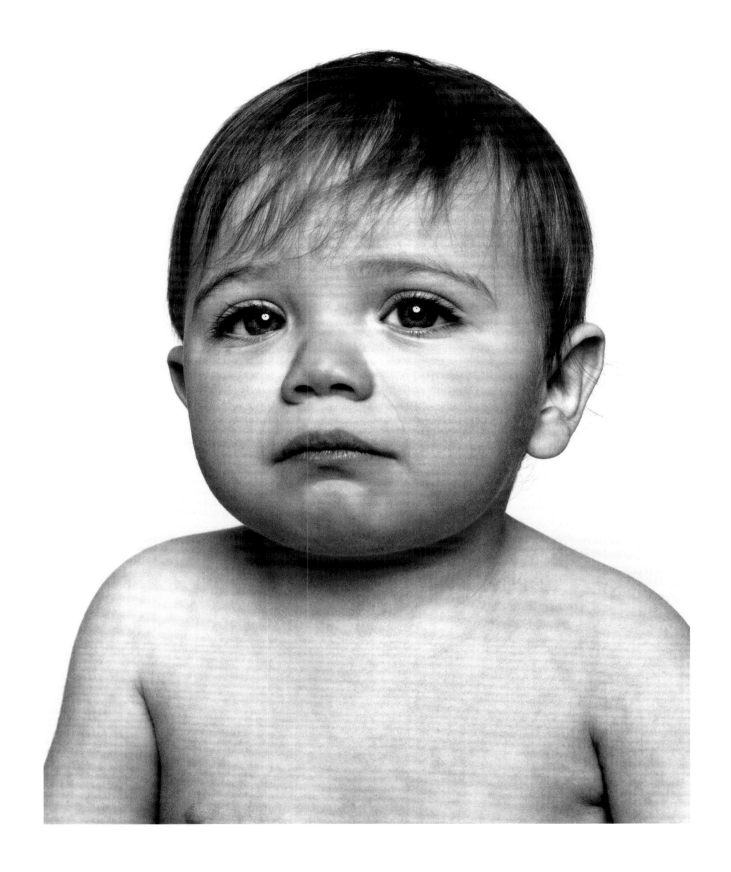

Saturday, January 9, 2010; 12:30pm

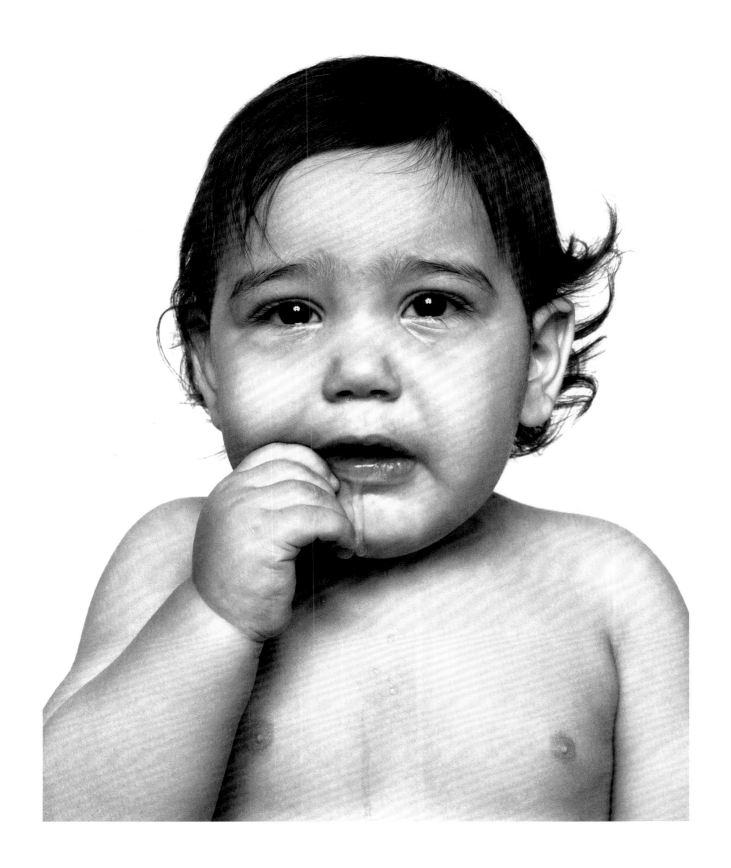

Monday, January 19, 2009; 9:21pm

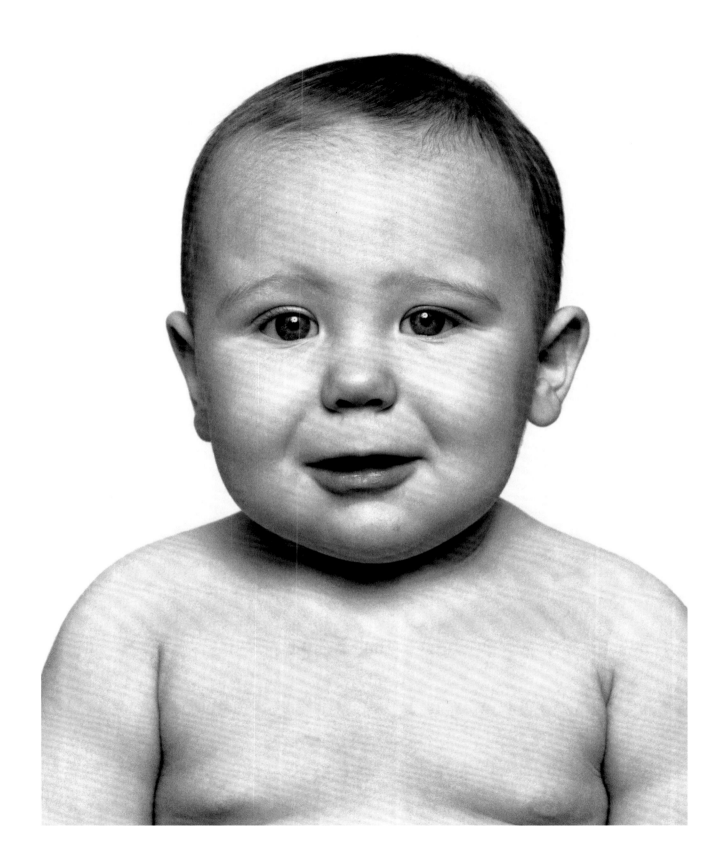

Sunday, February 13, 2005; 4:49am

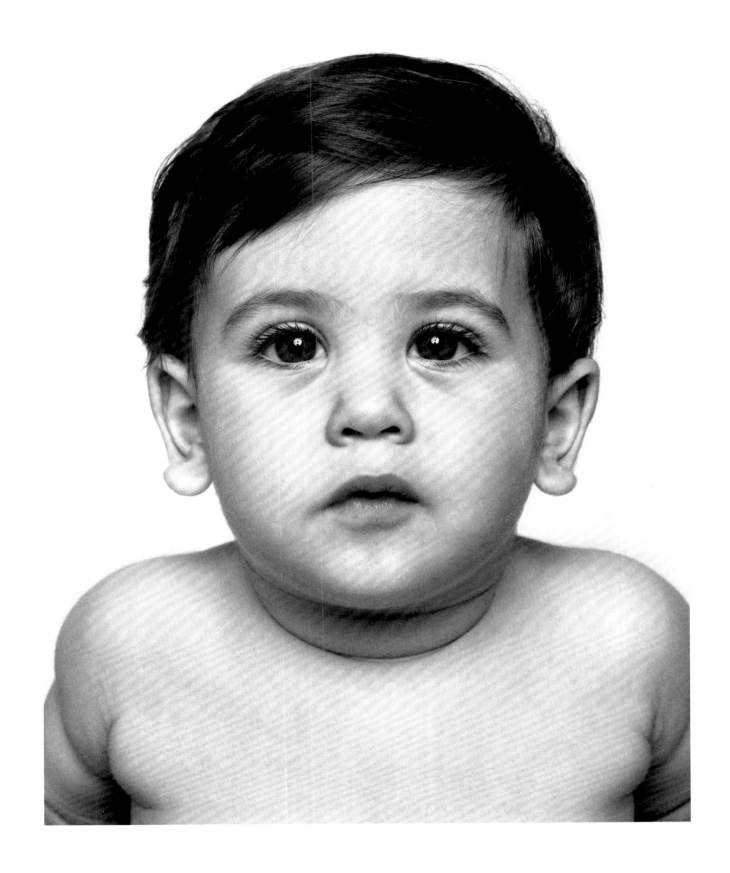

Thursday, February 14, 2008; 1:39pm

CONSCIOUSNESS
JUST *the* SAME

Looking at the bright clear faces, at these features so unmistakably individual and distinct, at these visible expressions of highly evolved personalities and complex inner lives, I found myself wondering why so few books of serious fiction have been written from the point of view of a one-year-old child.

The answer might seem obvious: Without language, and (we assume) an ordered or conventional sense of time, one-year-olds lack the basic elements required for a narrative. Or perhaps they merely lack the words in which to tell us what those narratives are. Or perhaps it's our fault: perhaps we ourselves are missing the imagination and skill to connect the dots that would form some version of their experience of the world.

The answer seems obvious, and yet . . . and yet . . . entire novels have been written from the point of view of bunnies, dogs, and birds. Do we think that, after twelve months of life, our children are less interesting, less worthy of our attention and our imaginative capabilities than our pets?

Of course, there are exceptions, brilliant examples of a writer's efforts to remember or intuit the sights and sounds of those early months. Most famously, *David Copperfield* begins with its hero's birth:

I record that I was born (as I have been informed and believe) on Friday, at twelve o'clock at night . . . In consideration of the day and hour of my birth, it was declared by the nurse, and by some sage women in the neighborhood who had taken a lively interest in me several months before there was any possibility of our becoming personally acquainted, first, that I was destined to be unlucky in life; and secondly, that I was privileged to see ghosts and spirits.

Reading these words, I can't help thinking that the urge to predict a person's future so early on reflects our perception—our strong suspicion—that a whole life can be read in the face of a person who has so far enjoyed only a year of it. Dickens goes on, as David Copperfield summons up memories of his mother "with her pretty hair and youthful shape" and the servant Peggotty, "with no shape at all." Wondering if he really recalls or imagines the touch of Peggotty's finger, he reflects, "I think the memory of most of us can go farther back into such times than many of us suppose; just as I believe the power of observation in numbers of very young children to be quite wonderful for its closeness and accuracy."

In the contemporary novel, *Mother's Milk*, Edward St. Aubyn writes beautifully about a young boy's memory of infancy:

Robert felt he could remember exactly what it was like being in that cot, lying under the plane trees in a cool green shade, listening to the wall of cicada song collapse to a solitary call and escalate again to a dry frenzy. He let things rest where they fell, the sounds, the sights, the impressions. Things resolved themselves in that cool, green shade, not because he knew how they worked, but because he knew his own thoughts and feelings without needing to explain them . . . Sometimes he imagined he was the thing he was looking at, sometimes he imagined he was in the space in between, but the best was when he was just looking, without being anyone in particular or looking at anything in particular, and then he floated in the looking, like the breeze blowing without needing cheeks to blow or having anywhere particular to go.

What these lovely passages remind us of is what we intuit from these photographs: that what we are looking at is consciousness, pure consciousness, without experience or language—but consciousness just the same. No wonder it is so difficult for even the imaginative to imagine. These one-year-olds are freer than we are, free to drift between their world and ours, their magic state of being with its single-minded awareness of a familiar touch and its invitation to float like the breeze. Then they can elect to tune into our world, the world of children and grown-ups, of others, the world filled with mysterious people whom the one-year-olds are learning to understand and read. Perhaps they are deciding whether to become like us, or not.

It's endlessly shocking, how small and helpless and at the same time how advanced and sophisticated they are. They know so much and so little. It's best not to underestimate how much they understand when they hear and watch us.

They have come a long way in one year. They have gotten a pretty good head start on collecting and amassing the basic elements of their essential selves. At the same time they still depend on us for food and water and diaper changes, in a word: survival.

At the tender age of one, they have already figured out how much or how little they want to reveal in the intense and complicated faces that look out at us. The children in these striking images are who they are. They are enlarged and expanded versions of their brief pasts and darling little distillates—concentrated versions of the people they will be in the future.

— Francine Prose

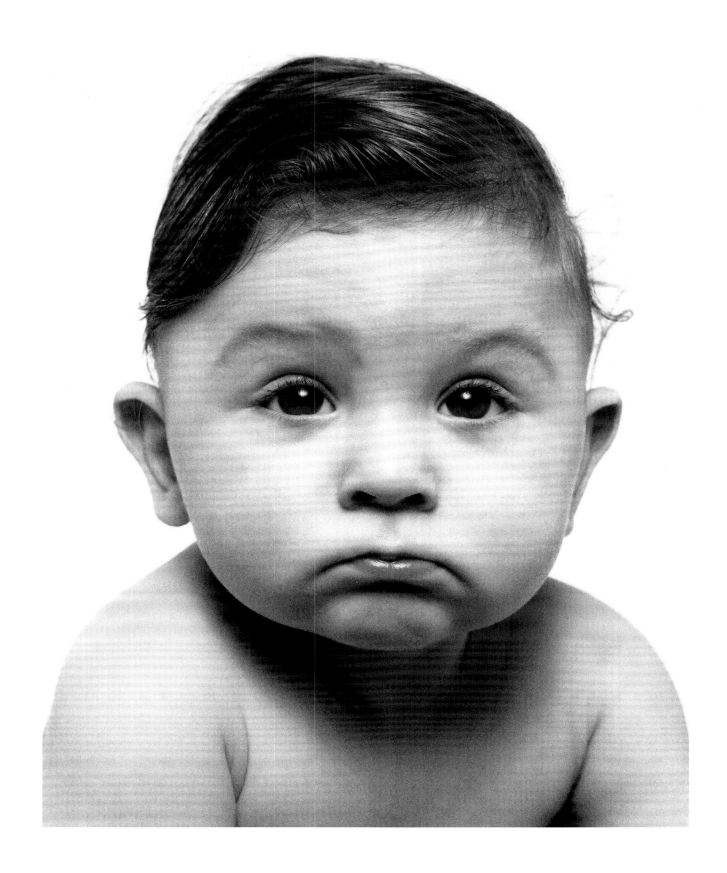

Sunday, September 3, 1995; 12:46pm

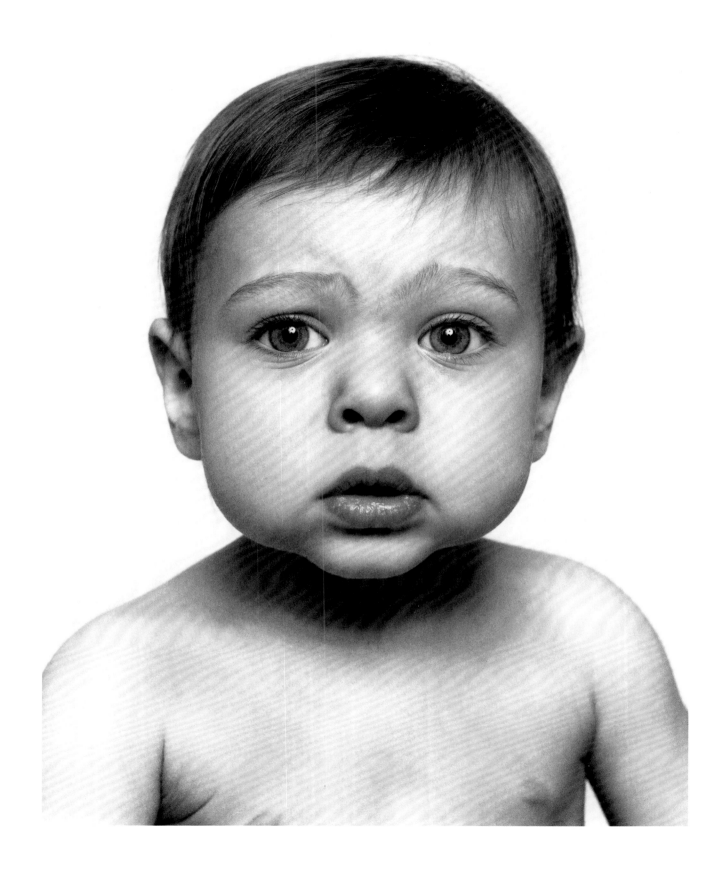

Tuesday, February 15, 2005; 5:32pm

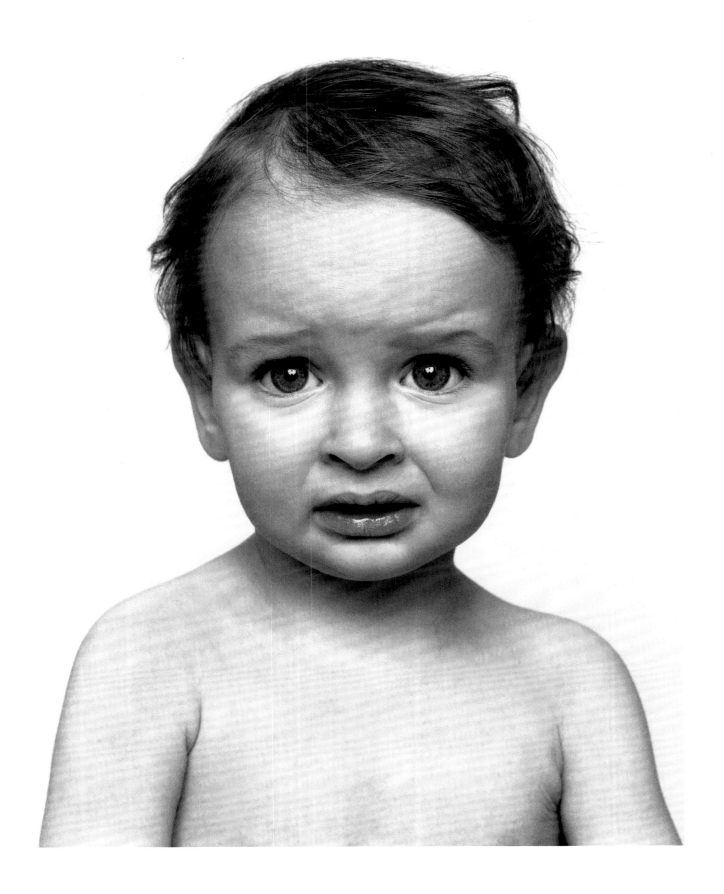

Wednesday, December 12, 2007; 6:09am

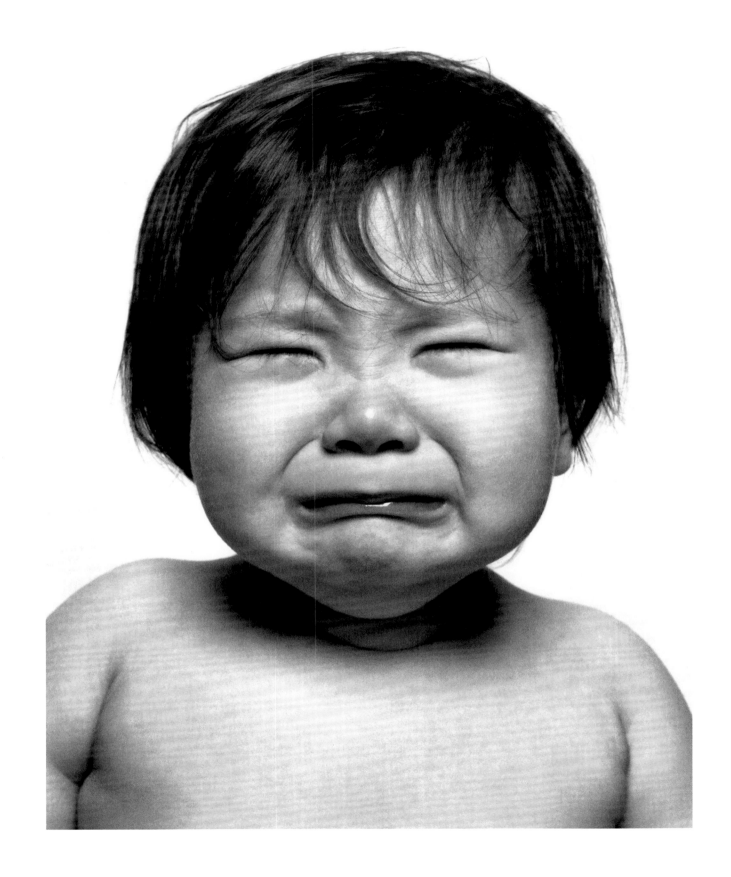

Tuesday, November 19, 2002; 1:53pm

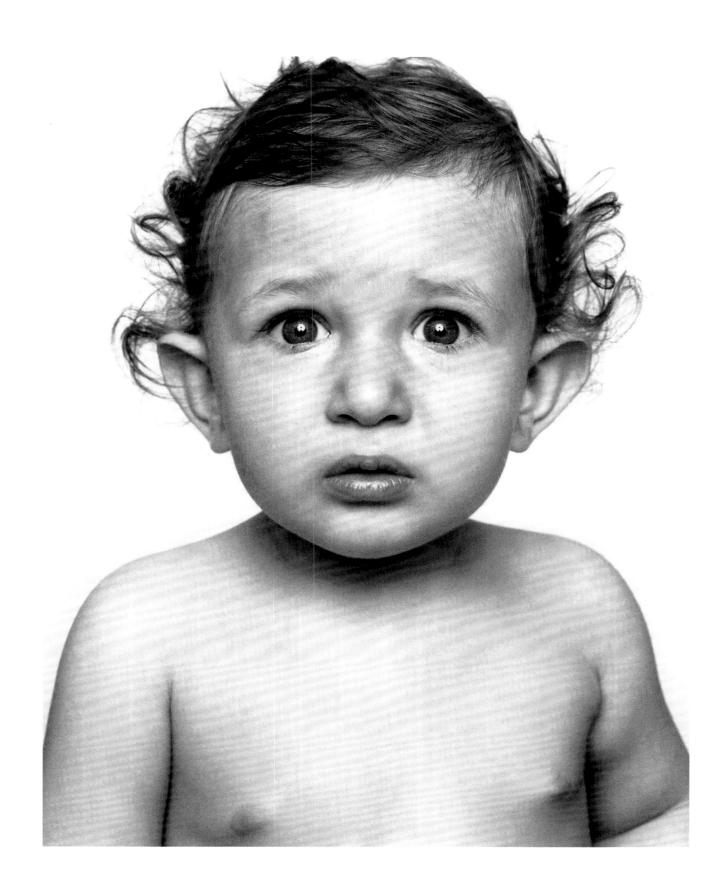

Saturday, April 19, 2008; 10:20am

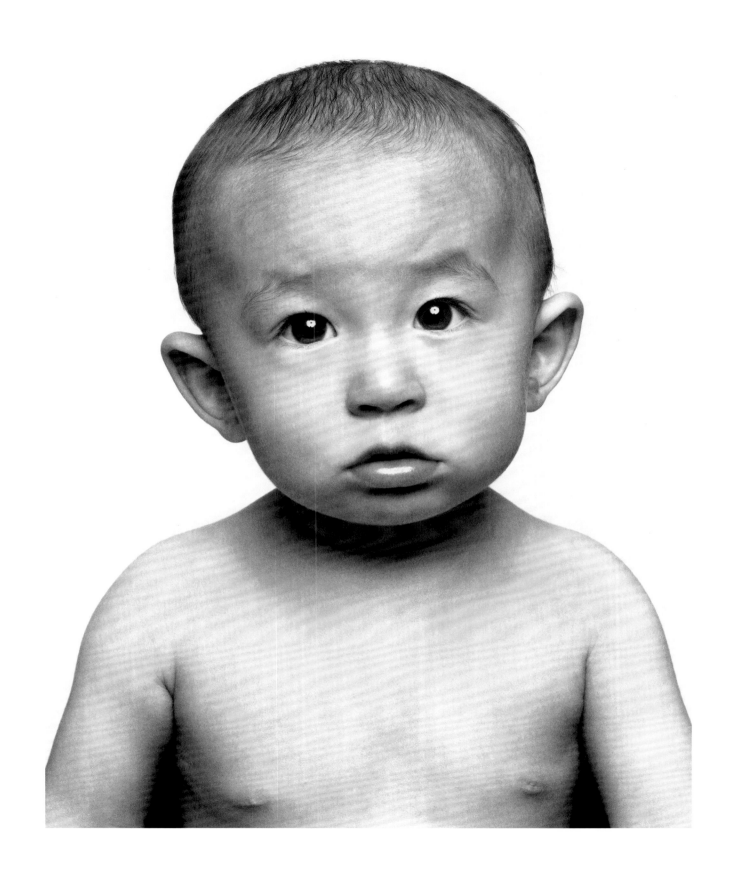

Sunday, September 14, 2014; 8:22pm

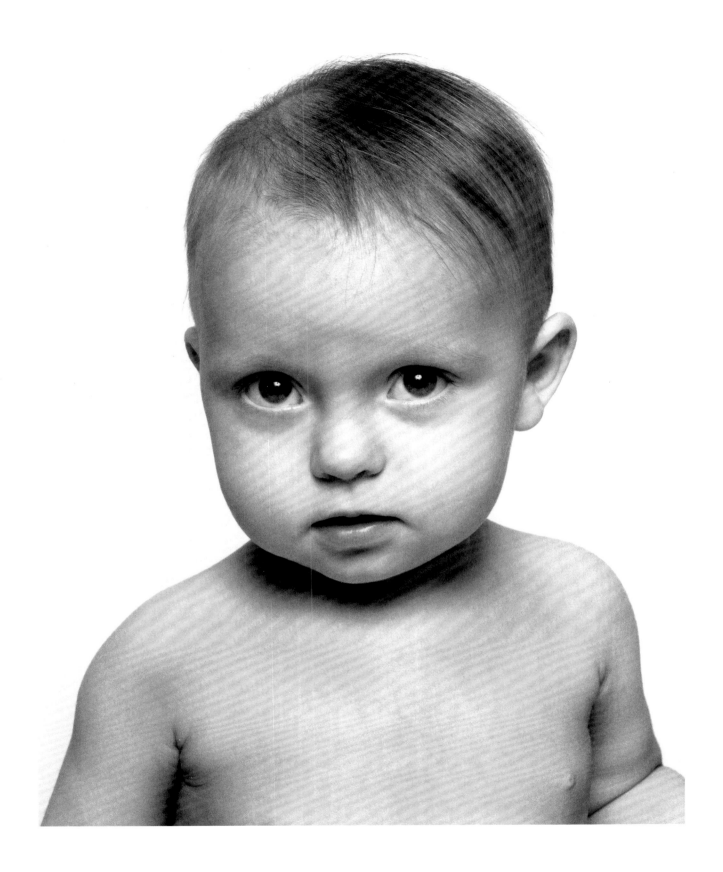

Thursday, April 12, 2001; 6:05pm

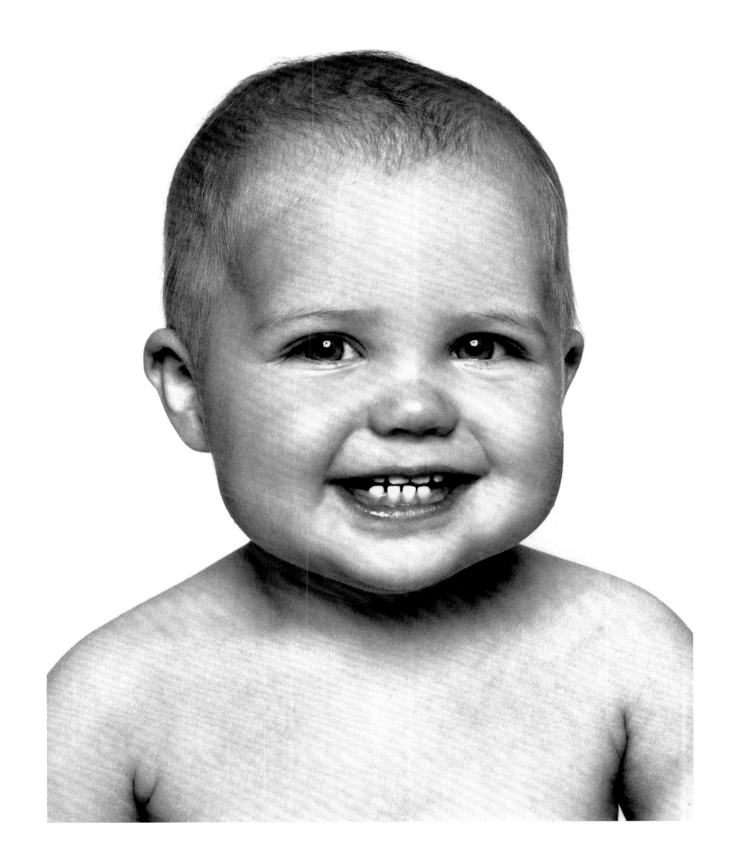

Tuesday, October 26, 2010; 7:41am

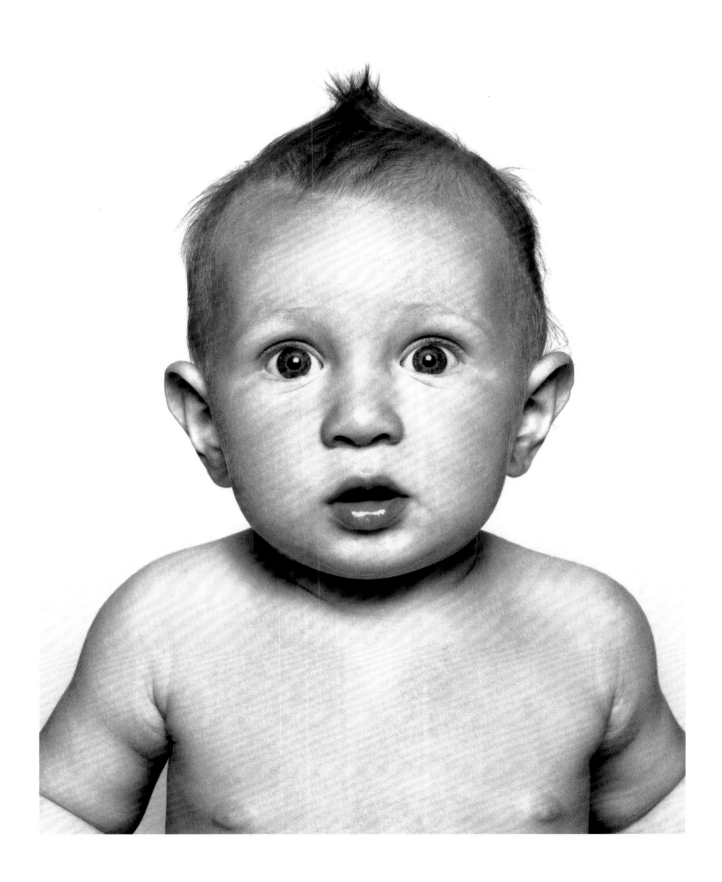

Saturday, November 26, 2005; 12:05am

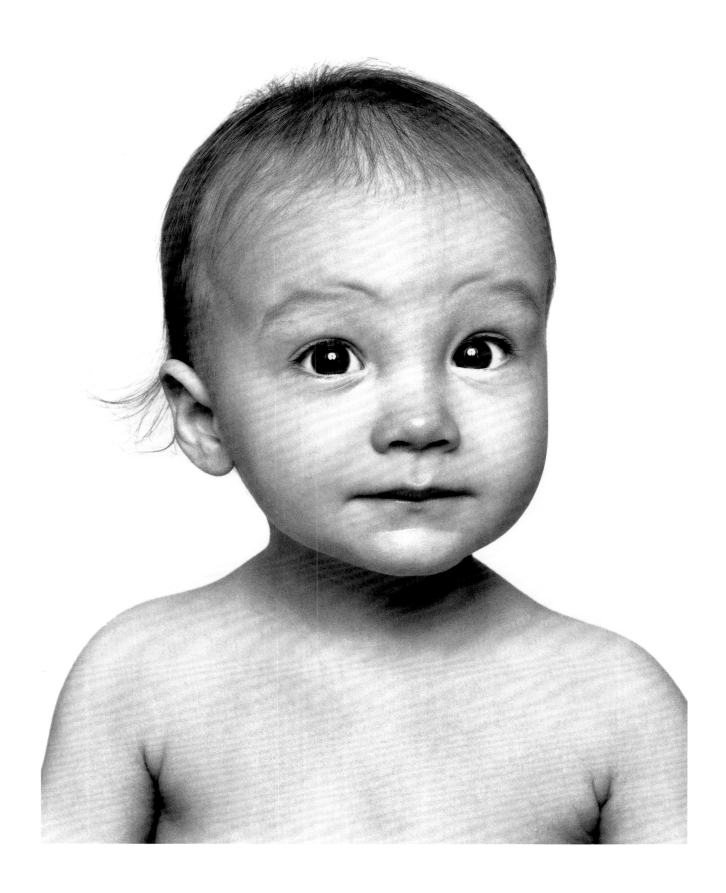

Monday, April 9, 2012; 5:44pm

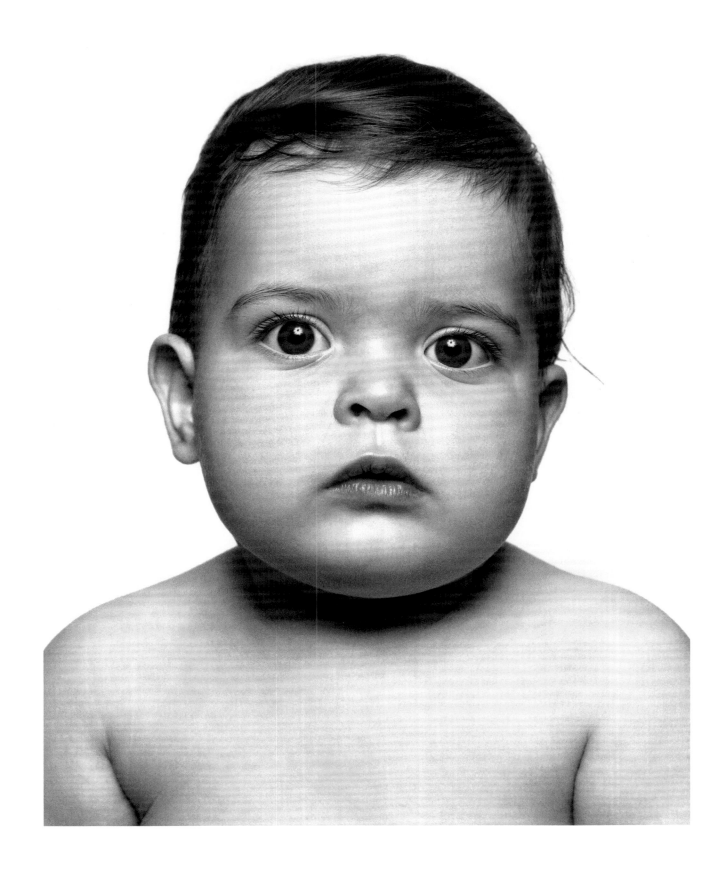

Wednesday, October 27, 2004; 10:12am

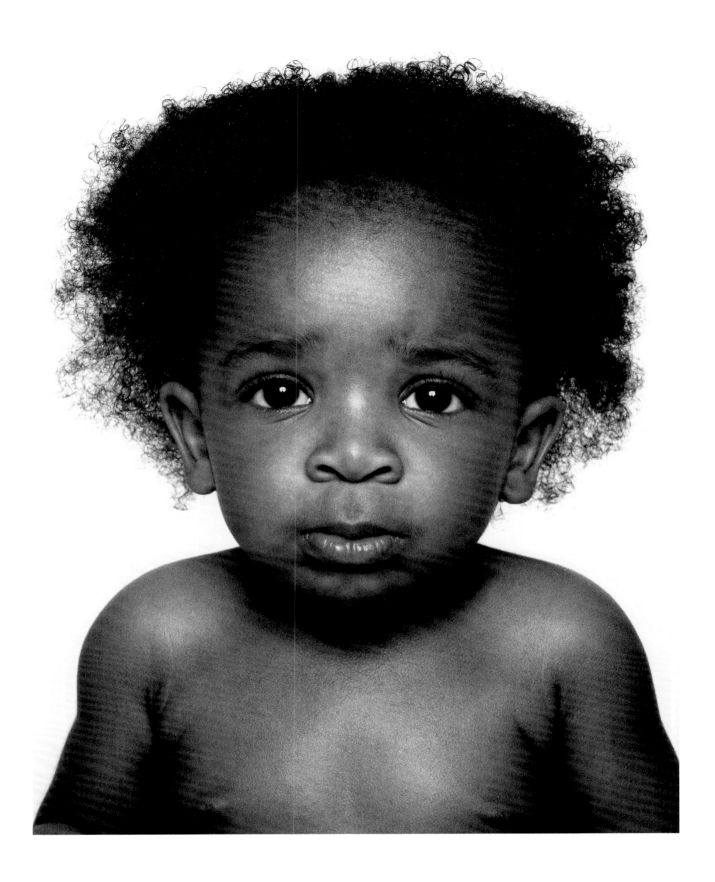

Saturday, September 3, 2005; 2:45pm

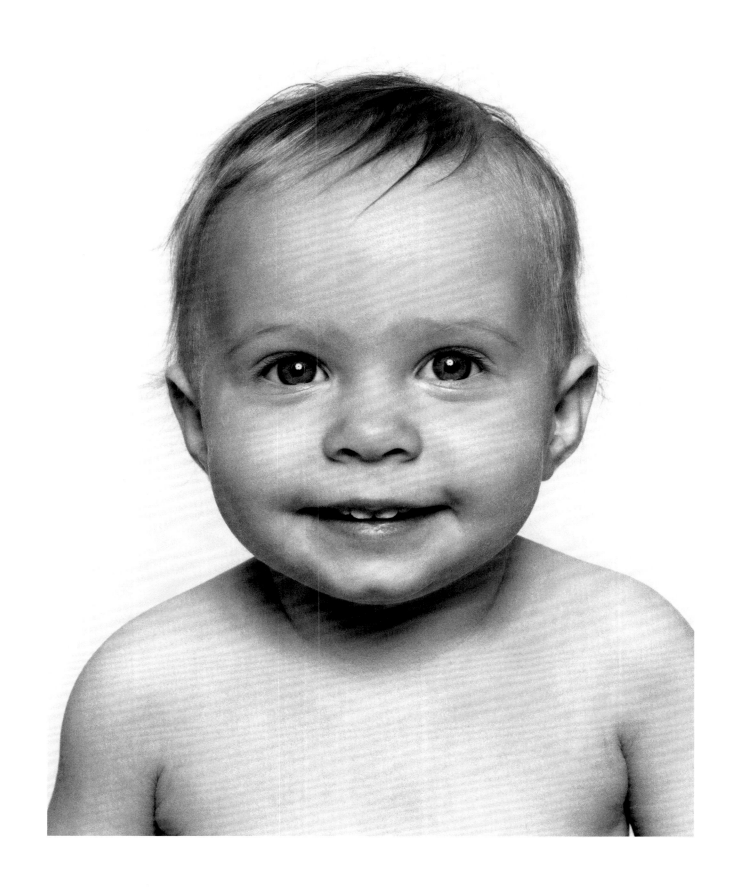

Friday, April 29, 2011; 2:15am

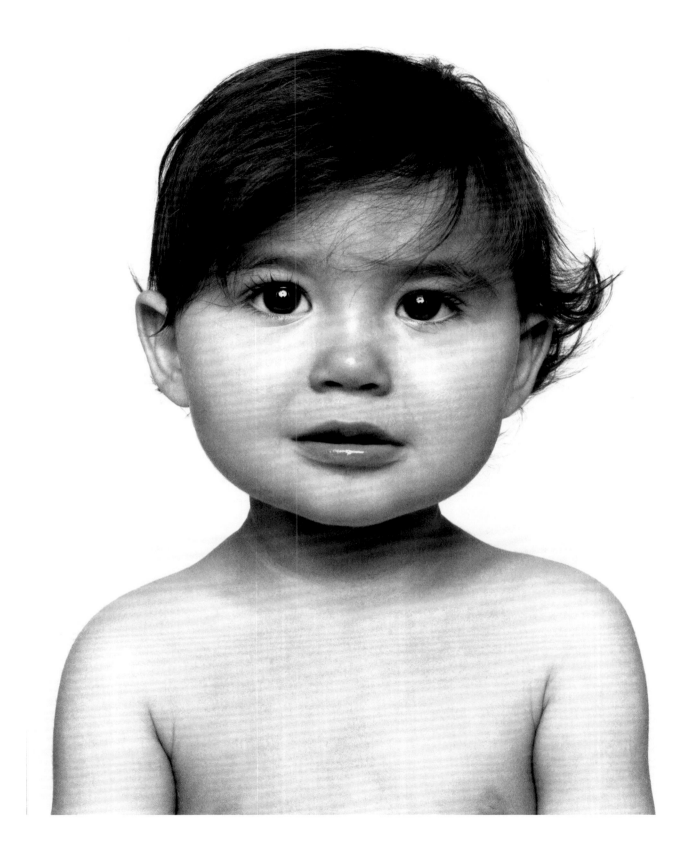

Friday, October 19, 2012; 9:15am

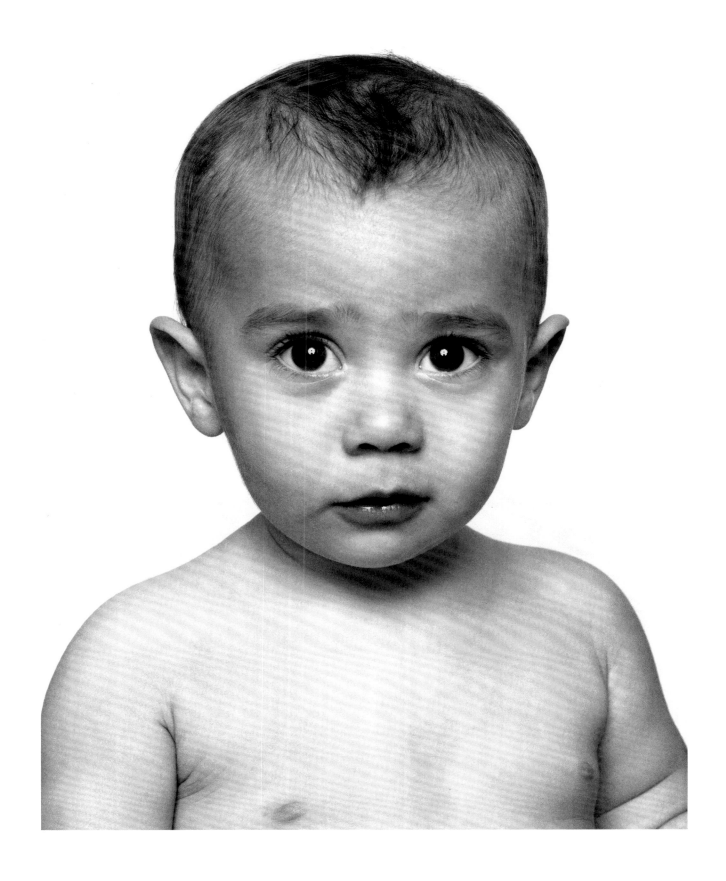

Wednesday, December 12, 2007; 4:21pm

BABY FACE

Historical consciousness—particularly art historical consciousness—is a poison that can become a palliative. A poison because it intercedes a horizontal, historical knowledge of other things like the picture you're looking at until they occlude the picture itself; a palliative because it prevents us from the malediction of thinking too much of newness, over-rating the melodrama of innovation. *There are other things like this thing* is, in effect, what every parent sooner or later says to every child—your problem is not unique and that is what the sane historian says to the audience, or even to the artist, though he should generally just shut up around the artist.

Looking at these portraits of one-year-old children, we can't help but think of others—the faces of the children shown here put us in mind of other children and of what we know of the child's mind. For when it comes to children, we are between myths. The old myth of childhood innocence—children as gleaming empty vessels, into which knowledge and experience might be poured—was replaced a century ago by the Freudian opposite, the myth of childhood as a time of buried trauma and uneasy sexuality and, above all, appetite: yowling for its mother's breasts or standing fascinated and shamed by its father's penis. The innocent child was replaced by the over-experienced child, who might spend her years trying to get over the experiences.

Those images of those childhood myths are fixed in place in art—the solemn kids of early American painting got replaced by the bright eyed eager citizens in the work of a painter like Cecilia Beaux, and were then replaced by the darker images of modernist art, either Matisse's entrapped child taking piano lessons or Picasso's scarecrow like six-year-olds (Lewis Carroll is one of the special exceptions, his images of childhood minds being at once smoldering and still, above all, sensible—his girls *think*, rather than *know*).

In recent years, though, there has been a kind of revolution in the way we understand children, and, with the strange synchronicity that enables artists to make images of things their more stutter-tongued thinkers can merely argue for in the same time, Mapplethorpe's portraits capture this. We are asked—by storytellers and psychologists alike—to think of children now neither as trauma-receptors nor as wide-eyed innocents but as minds, explorers, even as scientists, taking advantage of the long extended childhood of our species to experiment with new ideas and find things out. The child is a theory tester, a knowledge collector, witty in its invention of imaginary friends, who she might make out of the mists and fogs of her experience into something distillate and fixed. And she is wise in her grasp of the strange rules of human interaction, knowing early and learning quickly the mysterious truth that other humans are not just sacks or robots but have minds just like her own.

Mapplethorpe's one-year-olds seem to me to be perfect realizations of this new, coming-into-being myth of the child. They look out at us, at the photographer, wide-eyed and adorable, but far from innocent. They are alert, avid, using those beautiful Disney eyes not to flirt adorably but to

see—to explore. Alarm fills the eyes of one child, but it is not the alarm of the Oedipally traumatized. It is more like the wariness of one who has accurately doped out the strangeness of the situation— *Who's this guy? What's his machine? Isn't this weird? Where's Mom?* We feel the child thinking, and we empathize with his puzzlement. Having your picture taken *is* a strange circumstance, deserving of some extended mental scrutiny. Another child has that on-the-brink-of-tears look that every parent recognizes—there is no pause so extended, so endless, so certain to end in only one way and still taking so long to get there, as the pause between a baby's recognition of hurt and its howl of hurt, or just injustice—but her hyper-bright eyes juxtaposed with her maiden-aunt frown makes her an image not of small-animal-damage but of human sensitivity. Whatever is happening to her, it isn't fair. Children's sense of fair and not fair emerges early, as the first social consciousness, and remains with us for life, making us care more about equity of treatment than goods obtained: as social scientists have shown, we turn down free money in later life if our partner is unjustly getting more. *It's not fair*, this one-year-old face says, and whatever *it* is, we know it isn't.

Sometimes, we see children at work, learning the odd rules of human interaction. The little boy with the CEO's smile has learned, or is learning, some of the tricks of disarming others—how quickly the panic, perceived so clearly by those other children, of the circumstance can be resolved by a sign of peace, of good intentions: the human half-smile. There are, indeed, so many of those kin. A powerful truth, captured by Mapplethorpe, is that the big, beaming "Say cheese!" smile beloved by bad photographers of kids is almost completely absent from their normal repertory of emotion. But those small smiles, hinted smiles, half smiles—flirtatious, or modest, or just inviting smiles— come to them as naturally as the first babbled words.

Half-tint emotion is the natural language of the human face. Wary, wise, inviting, intelligent, concerned—all the necessary contradictions of human character shine. There are comic moments, too, of course, produced by the continuities of human expression that Darwin loved to study: one child has *exactly* the expression of a studio suit in her thirties listening dubiously to a doomed pitch.

There is a false comedy of these continuities: "Doesn't she look just like Winston Churchill (or Uncle Fester, or someone)?" we say of a small child, and, even if she does, we still are annoyed by the reduction. No, she looks like her. The resemblance of the young to the old is, most often, mere accident of wrinkles, the kind produced by baby fat rhyming with the kind produced by age. But there is a true, high comedy of these continuities, too, made by the genuine universality of human character. Wherever people are found, babies embark upon the long and anxious and ardent job of becoming one. They learn how to make their plastic faces become the clock dial, the encoded read-out, of their peopleness. Seeing them do it, we see neither reflex nor innocent romance. We see very young men and women at work, becoming human.

— Adam Gopnik

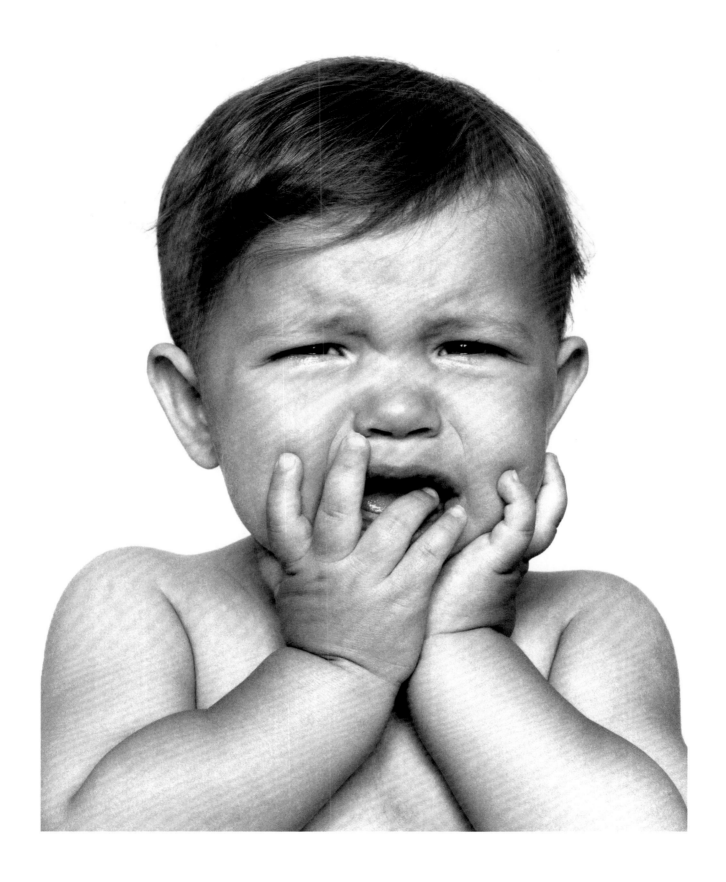

Sunday, June 19, 2011; 3:04pm

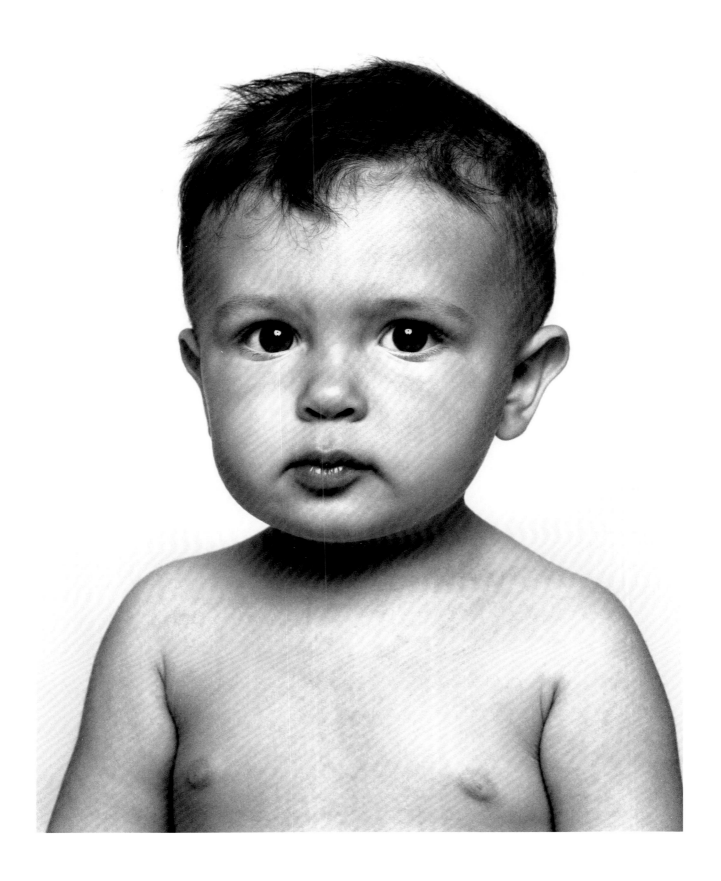

Saturday, April 4, 2009; 11:04pm

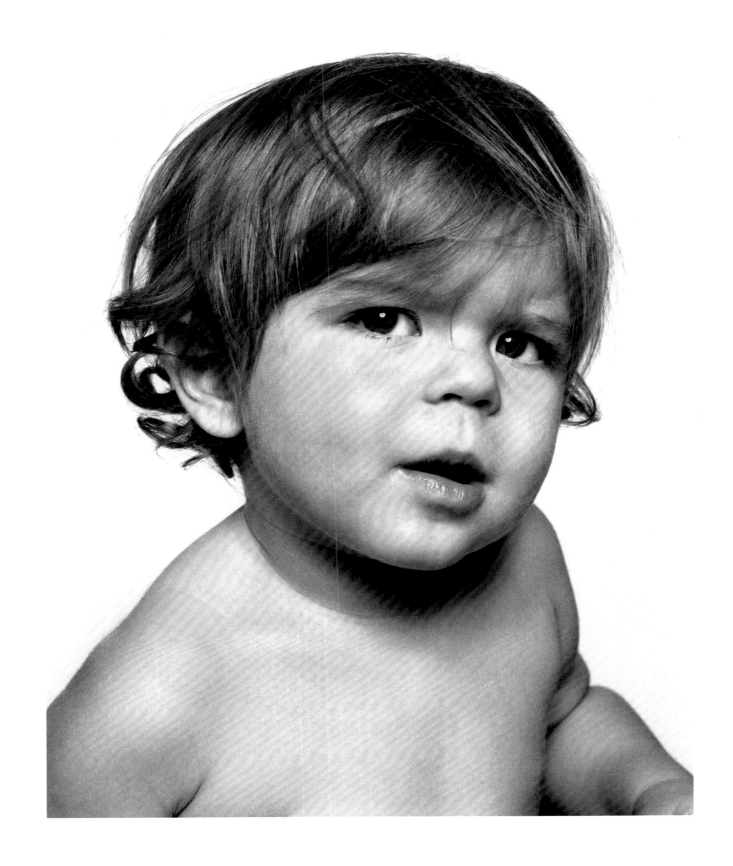

Sunday, August 3, 2003; 9:26pm

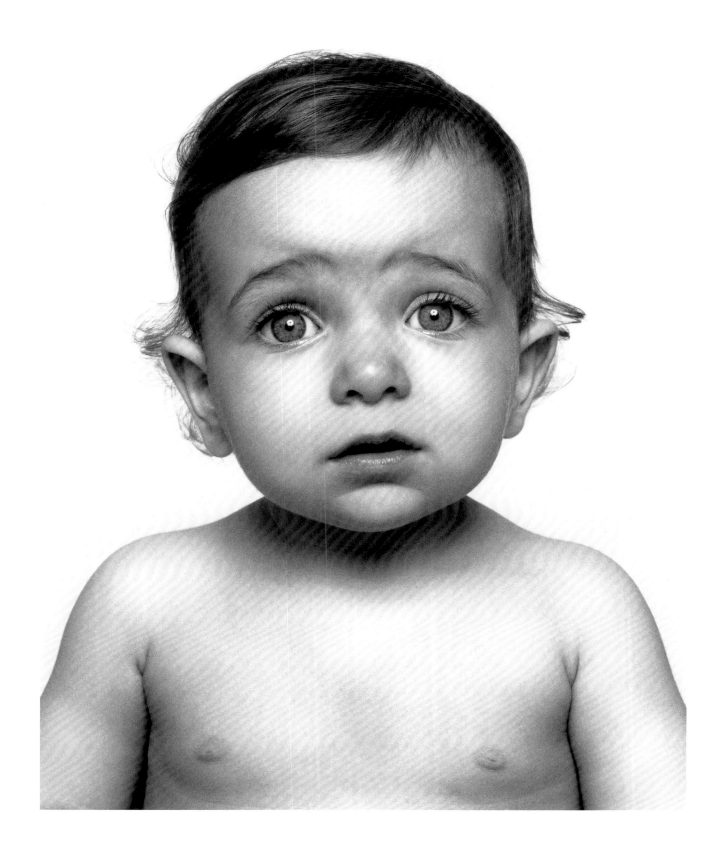

Tuesday, November 28, 2006; 3:27am

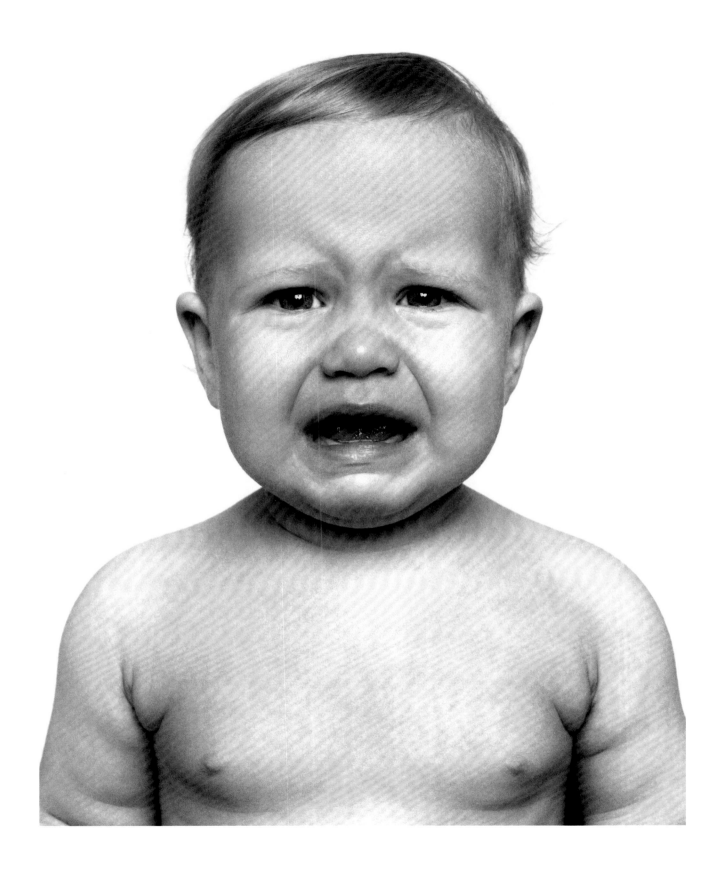

Saturday, May 20, 2006; 3:57pm

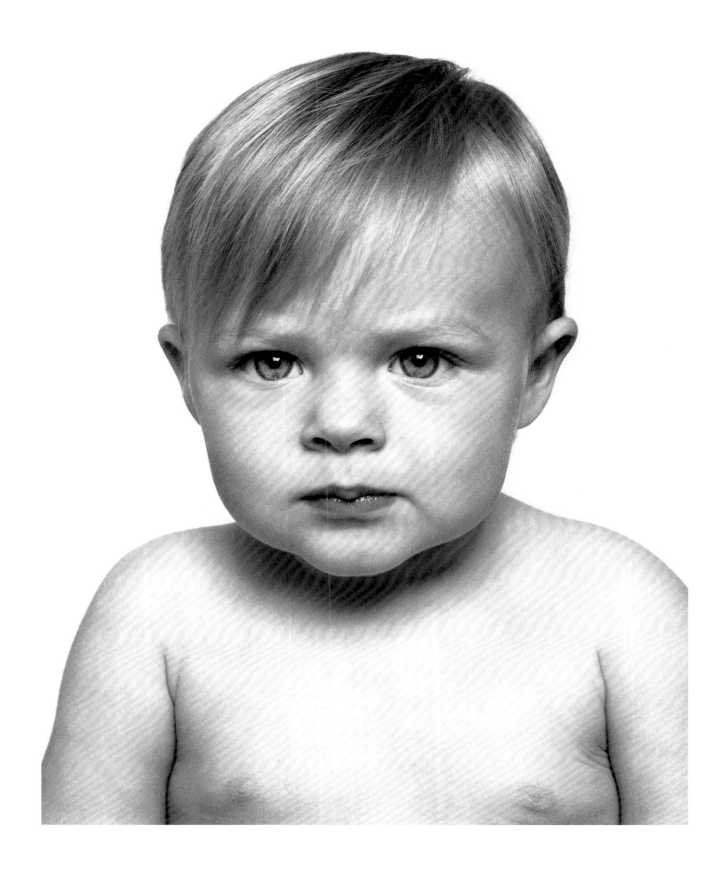

Sunday, September 7, 2003; 5:20am

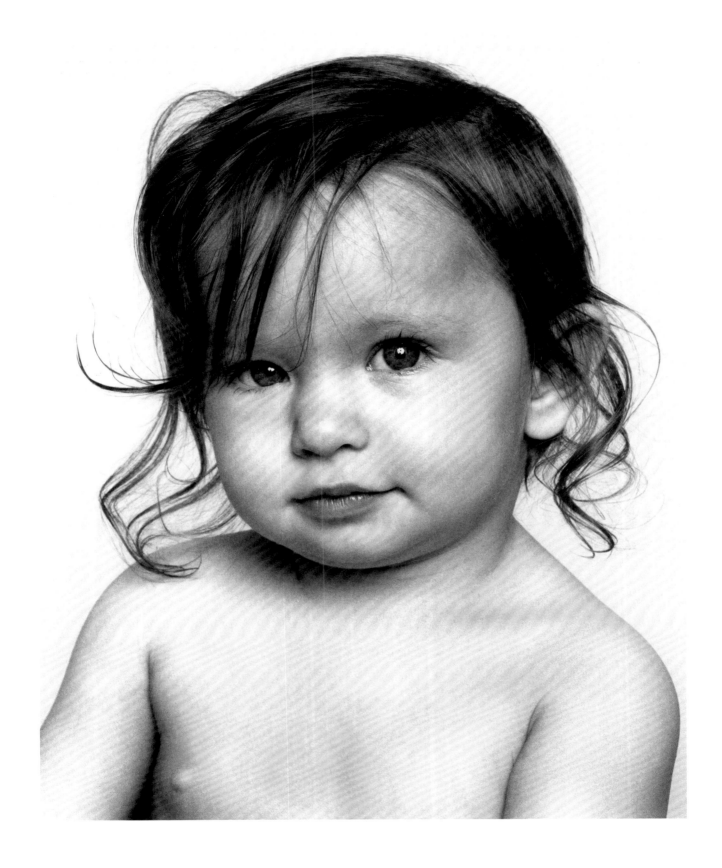

Wednesday, November 10, 2010; 2:17pm

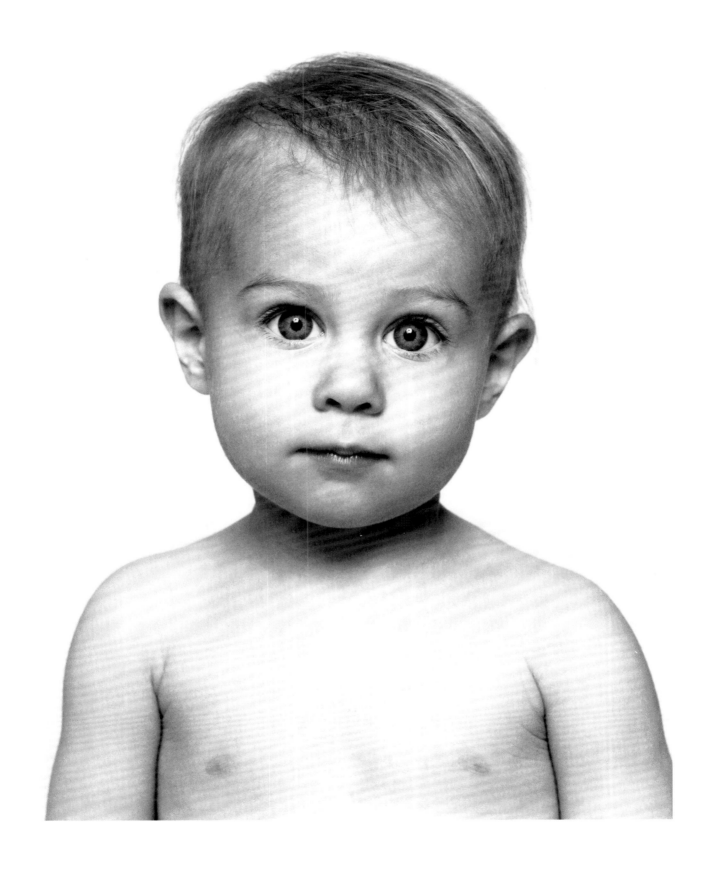

Sunday, March 6, 2005; 7:44am

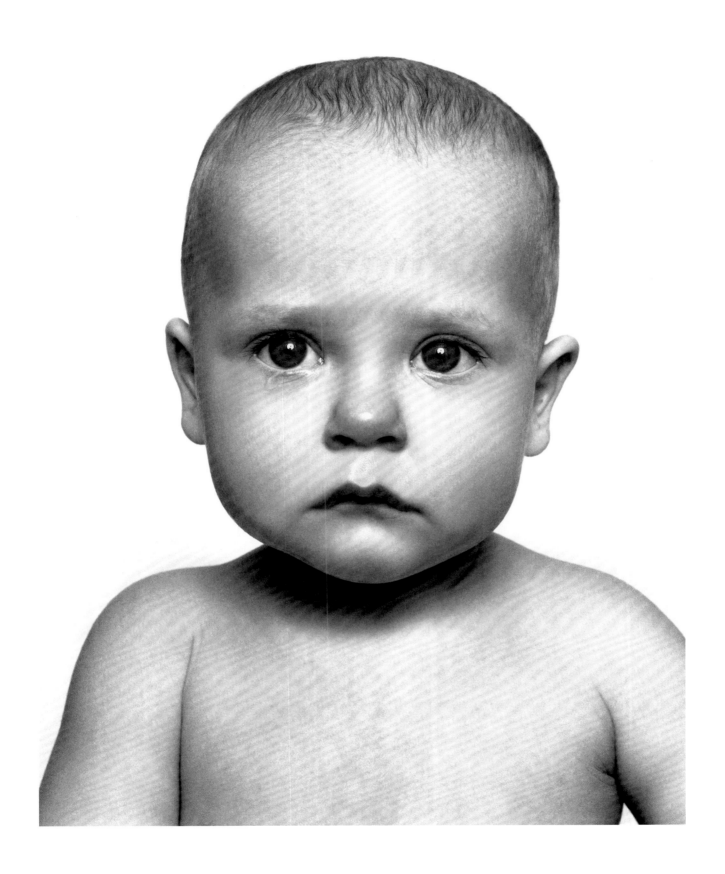

Saturday, March 27, 2010; 12:26am

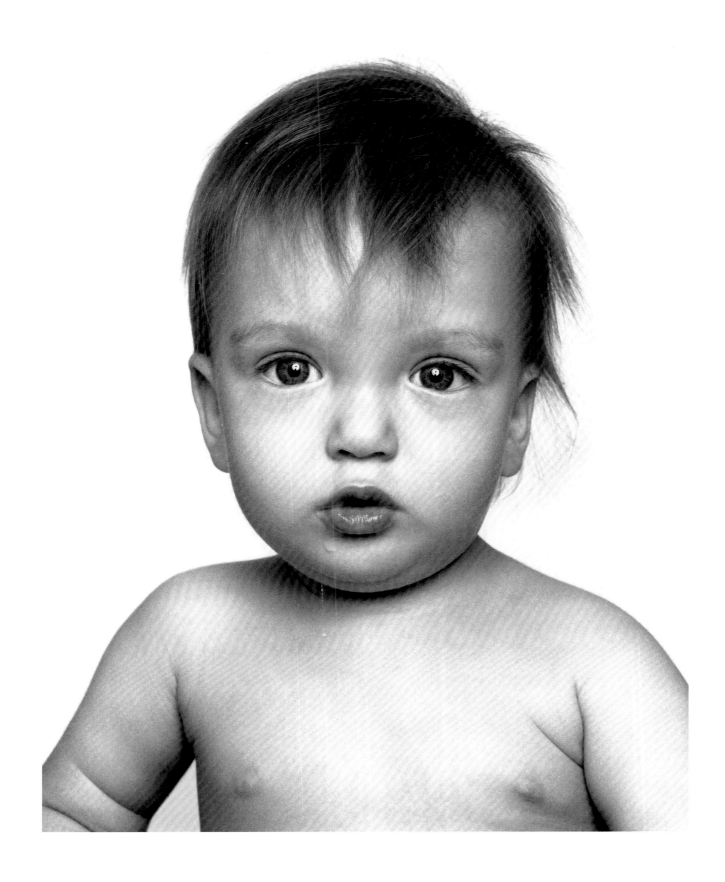

Tuesday, June 19, 2007; 1:43pm

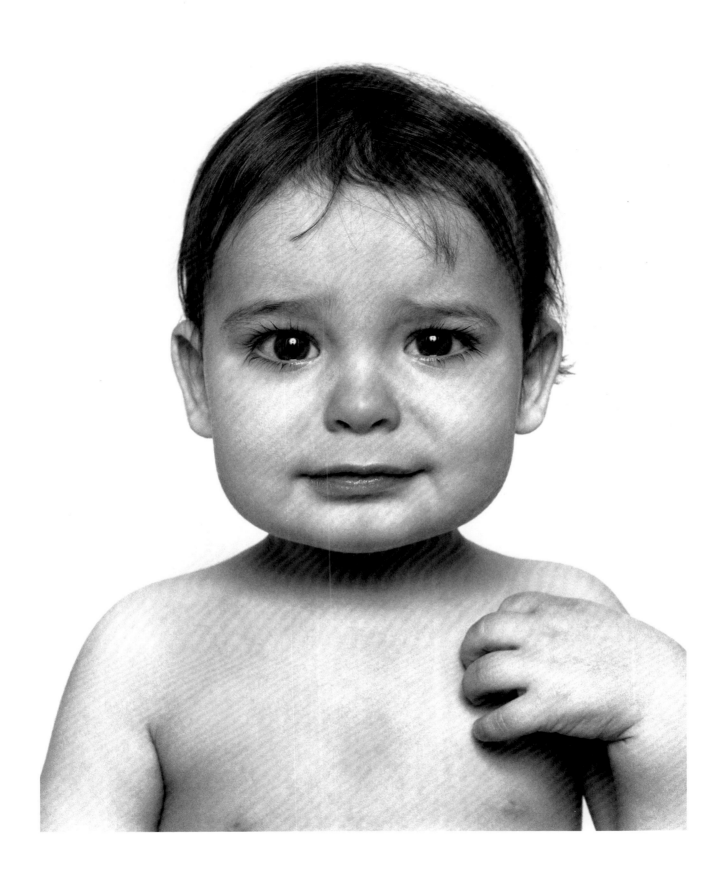

Wednesday, April 27, 2011; 10:29am

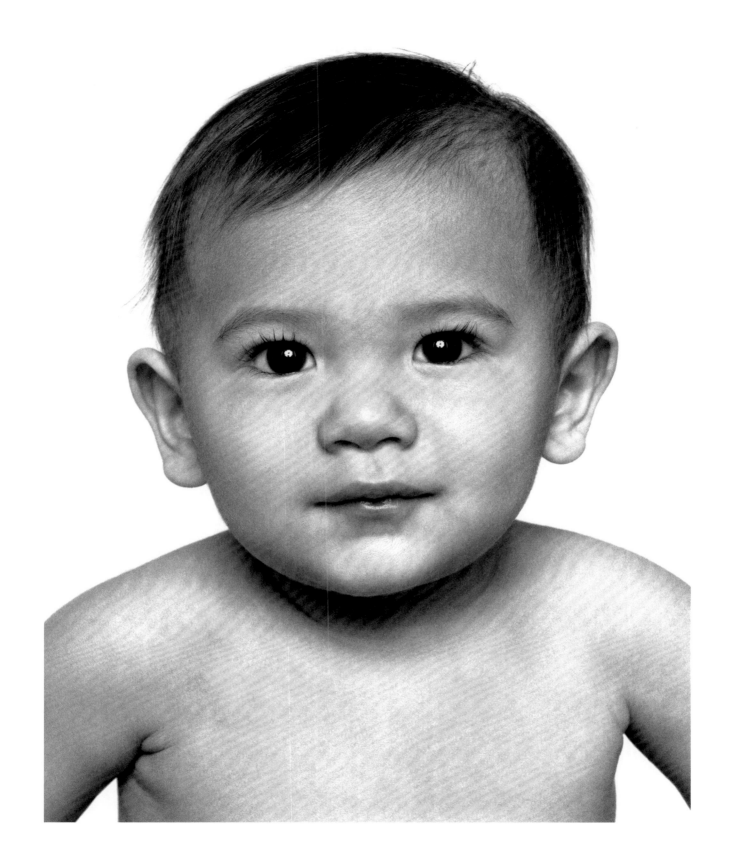

Friday, March 2, 2012; 5:18pm

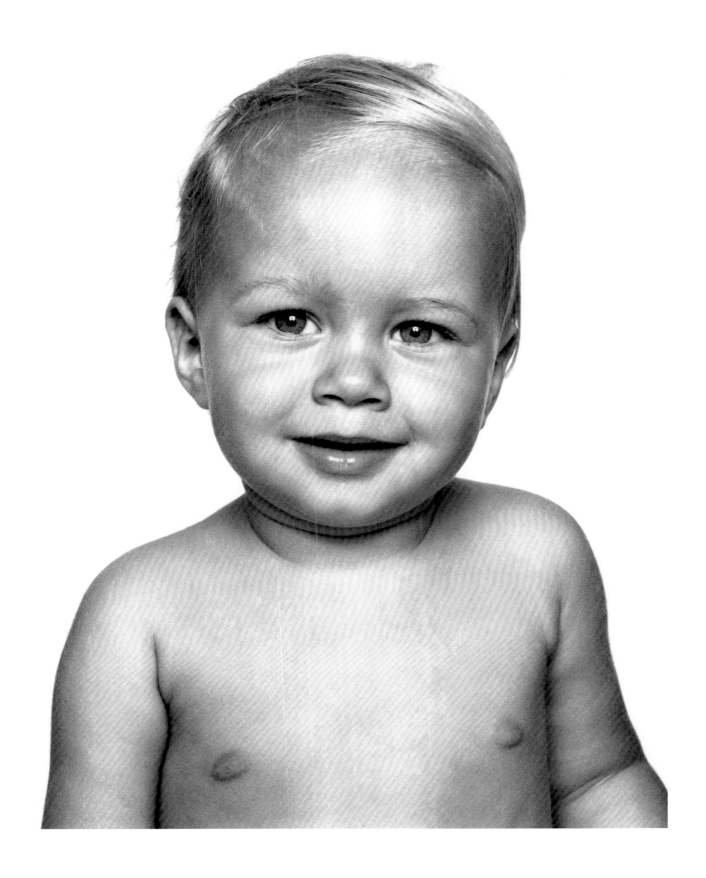

Wednesday, April 20, 2005; 7:30pm

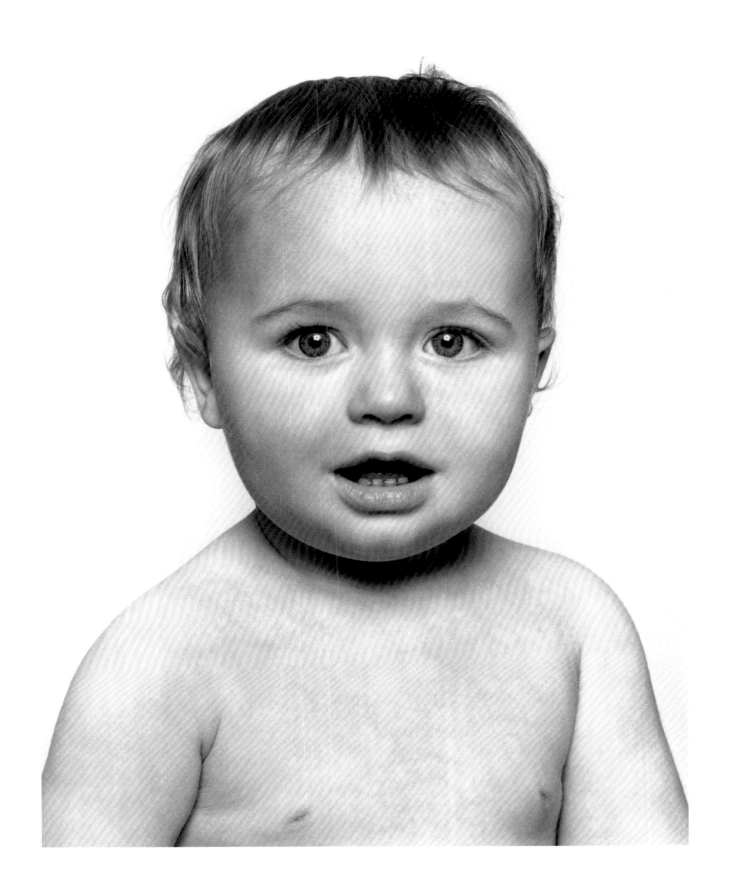

Friday, January 11, 2013; 6:40pm

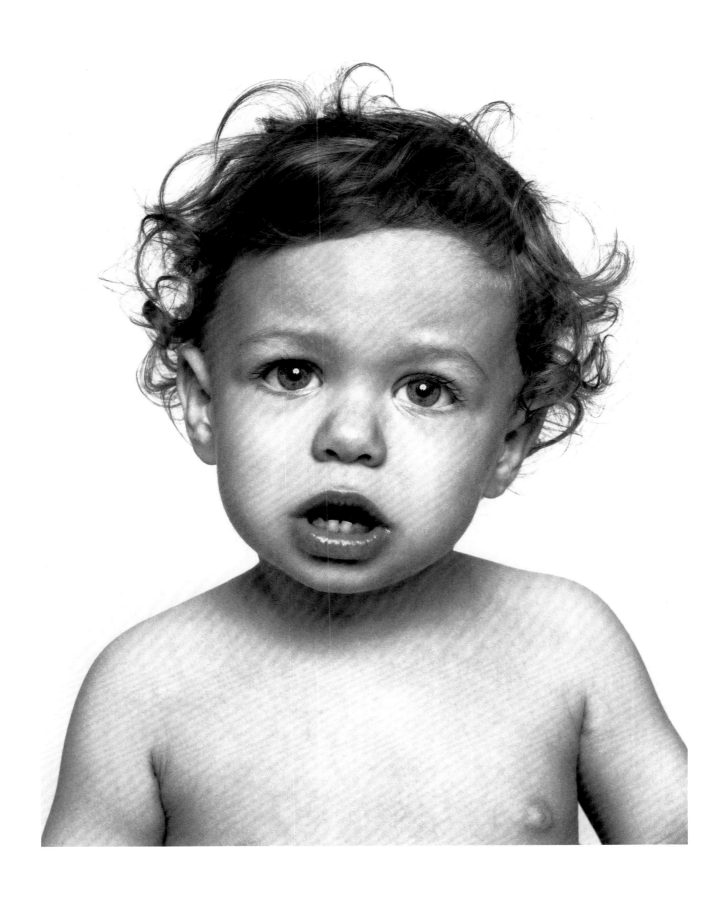

Wednesday, June 16, 2010; 10:00pm

the LOOK

The first time I was alone with a baby was one muggy afternoon in the lazy aimless summer between my sophomore and junior years in high school. This might sound shockingly late in life for a girl to solo for the first time with an infant, and even now, thinking back on it, realizing how old I was, remembering how many other firsts I'd already had by then, I'm astonished. But at the time, I didn't actually know a single baby. I was the youngest of three kids; the youngest of all my cousins; one of the youngest of the gang of children that populated my neighborhood; I was the youngest in my class at school by almost a year. I was used to being the baby, not used to being around anyone younger than me.

When I reached the age of capitalism and was seized with the desire to make money, I didn't skew toward the obvious choice of babysitting, even though most of my friends had discovered what a gushing revenue stream it was. I was so oblivious to children that babysitting never occurred to me. Motherhood was simply an abstract concept; I planned on having quite a few kids, perhaps six, when the time came, but until then they were as notional to me as life on Mars. I did want to work, but my wish was to be an attendant at a gas station or an exercise walker at the thoroughbred track near my parents' house. There was not even a nanosecond during which my parents considered allowing me to do either one of these, so I was stuck piecing together odd jobs—walking the neighbors' dogs, helping my mother weed the garden.

That summer, the one when I was a restless fifteen, too old for camp, too young to do a proper job, a new family moved onto our street. My mother told me they were a young doctor and his wife. The moving truck arrived one warm morning, and I wandered down the block to watch. After the truck disgorged their boxes and furniture, out came a pile of infant things—a stroller, a playpen, a high chair, a bouncer, some items I couldn't identify but, because of their glaring color and plastic sheen, I knew belonged to someone young. A baby on the block. I went back to weed the garden.

My mother belonged to the generation that believed in welcome wagons, so the next day she whipped up a batch of cookies and collared me, and we marched down the street to say hello. Mrs. P. met us at the door, and we made our way in through the obstacle course of moving boxes. She was dandling her baby, who was fat and pink, and had her dark hair tied up in a bow on the top of her head so it fanned out like a tiny palm tree. Mrs. P. and my mother got acquainted while I sat in a grumpy heap. The baby was named Sharon and she sucked on a pacifier and fixed me with an unblinking gaze. I stared back. We stayed locked in this eye-to-eye standoff until my mother poked me a few times, making cheerful noises. While I had been staring down Sharon, it seems, I had been hired to be a mother's helper for the rest of the summer.

Whether Mrs. P. knew of my complete lack of experience with babies, I'll never know, but I suspect she did, because most of what she had me do was fold laundry and empty the dishwasher and set the table and unpack boxes, while she tended to Sharon. Otherwise, I would have had to admit to her that I knew not one iota about baby husbandry: I had never in my life held a baby, had never burped one, and had never changed a diaper. The truth was actually bigger than that. It wasn't just that babies mystified me; I was terrified of them. Sharon was a placid, burbling little girl, but she was also, now and again, fitful and belligerent and weepy and implacable—in other words, she was an entirely typical baby. To me, though, unfamiliar with the infant disposition, she seemed like a tiny human bomb, silently ticking, waiting to be set off by something invisible. And when she wasn't wailing or fussing and was content and calm, she had that gaze—steady, intent, patient—that unhinged me. I was convinced she was taking my measure, seeing my inexperience and terror, knowing my soul and all its inadequacy. She seemed wise and I felt small.

I hoped my duties would stay limited to household chores, but one afternoon, Mrs. P. said she had to run to the store and that I should stay behind with Sharon. I stammered, but she had already gathered up her pocketbook and after giving Sharon a pat on the head, she headed out the door. The house was suddenly still. A clock somewhere clicked off the seconds. Sharon was in her playpen, noodling around with a toy. I convinced myself that if I didn't breathe, everything would remain fixed, quiet, and manageable; I would just sit here and in no time Mrs. P. would return. I eased myself into a chair. My heart was thudding. After a moment, Sharon looked up at me, solemn as a judge. I looked at her. She looked at me. And then, with perfect timing, we both began to cry.

I will never know if my mother and Mrs. P. had planned this, or whether it was pure and simple coincidence, or whether my mother was gifted with that mother's instinct that hears all and knows all and simply felt the tug to come down the street, but as we two babies sobbed and sniffled, my mother suddenly, magically, materialized at the front door. This made me cry even more, out of relief and embarrassment and a sudden upwelling of awe and wonder at my mother. She gathered us both up, her arms as big as the world, and blotted Sharon's tears and then mine.

— Susan Orlean

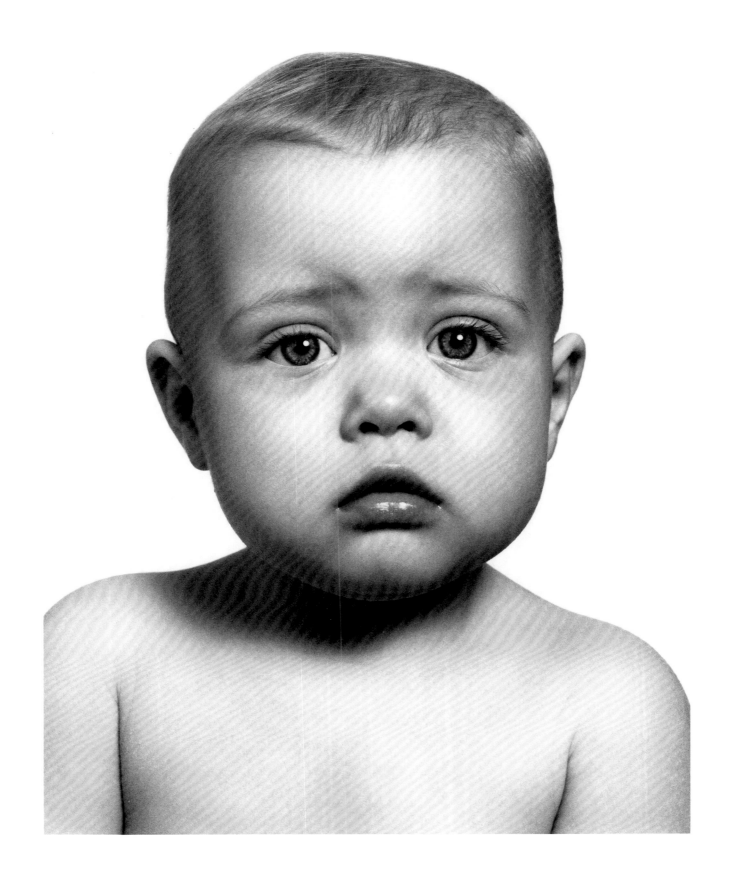

Wednesday, December 7, 1994; 6:50pm

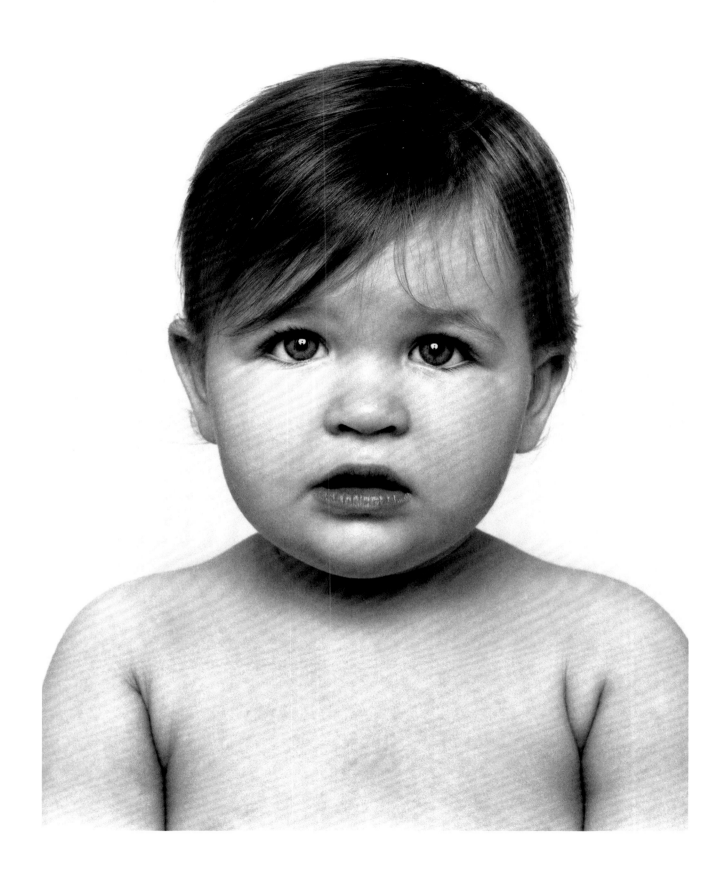

Wednesday, August 21, 2013; 10:29am

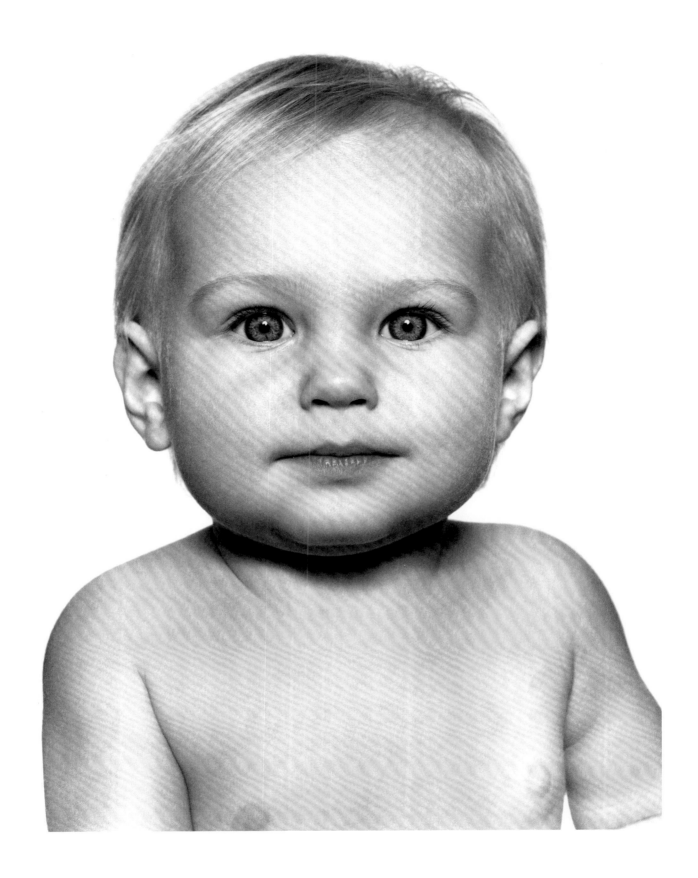

Wednesday, November 6, 2002; 4:45pm

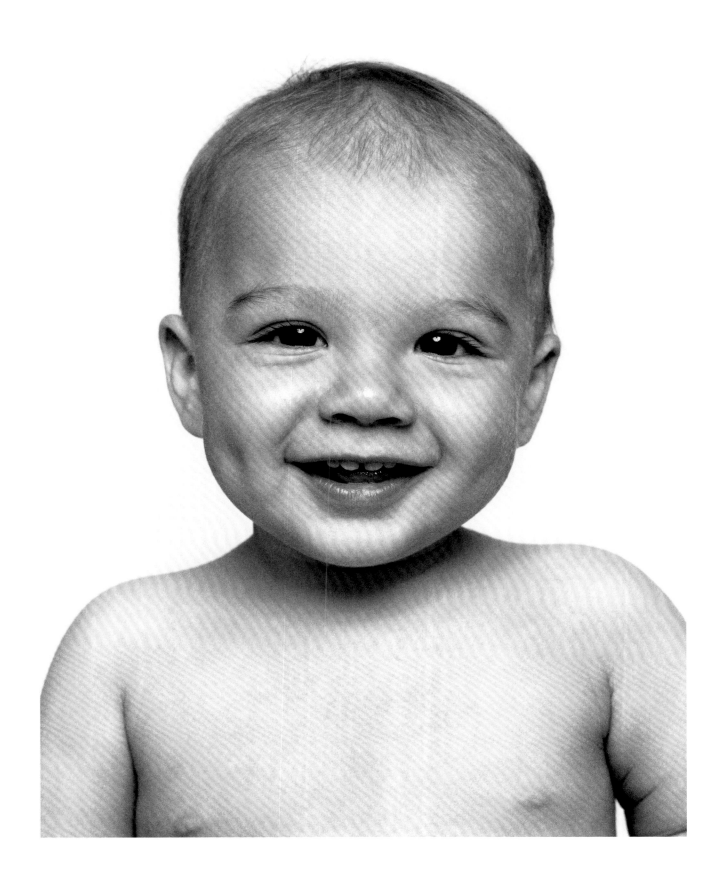

Thursday, September 17, 2009; 1:30pm

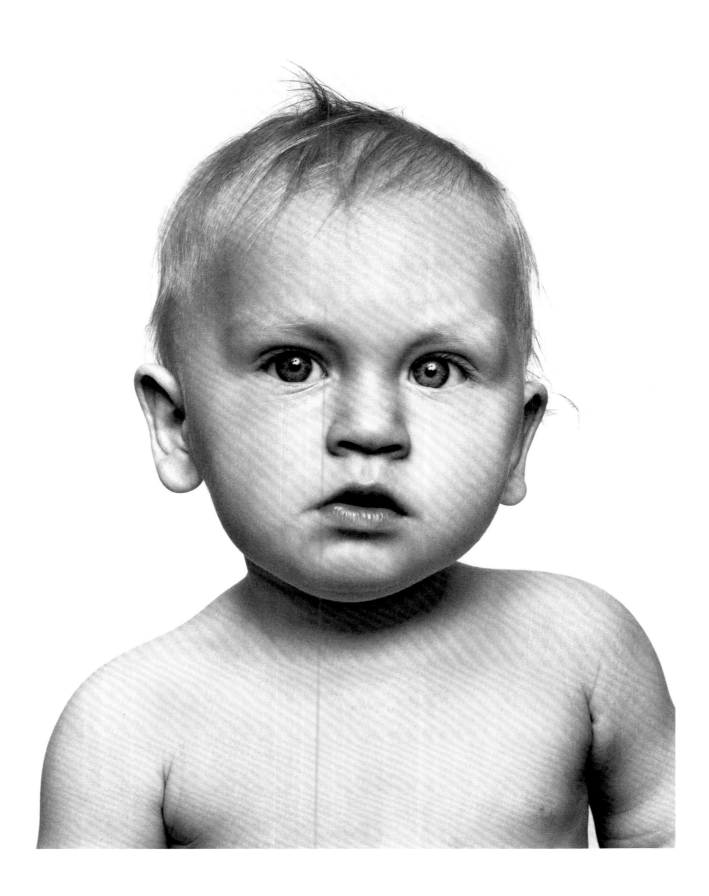

Wednesday, April 23, 2008; 1:52pm

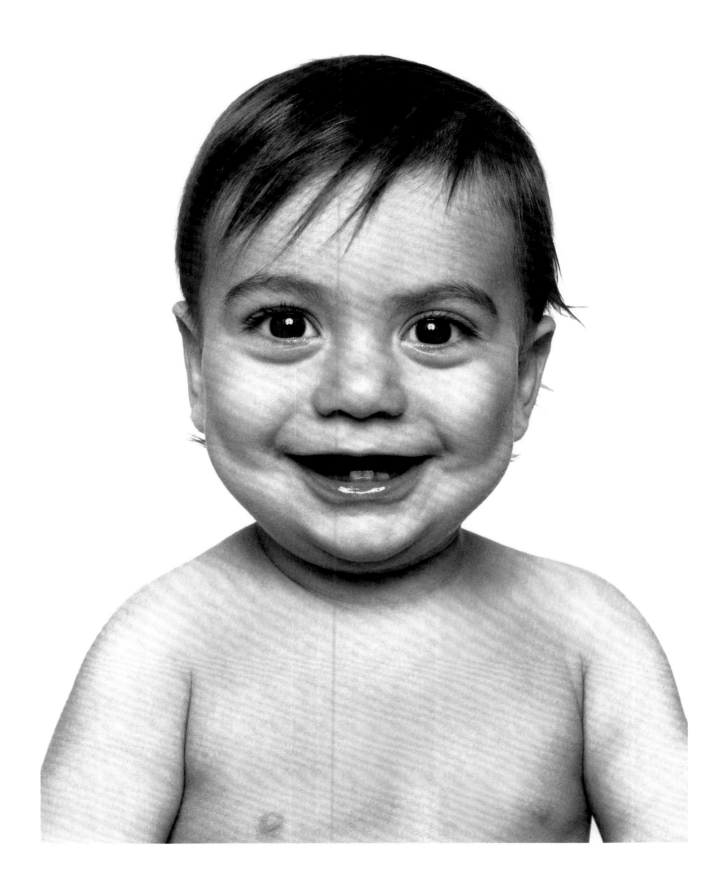

Monday, May 10, 2010; 5:10pm

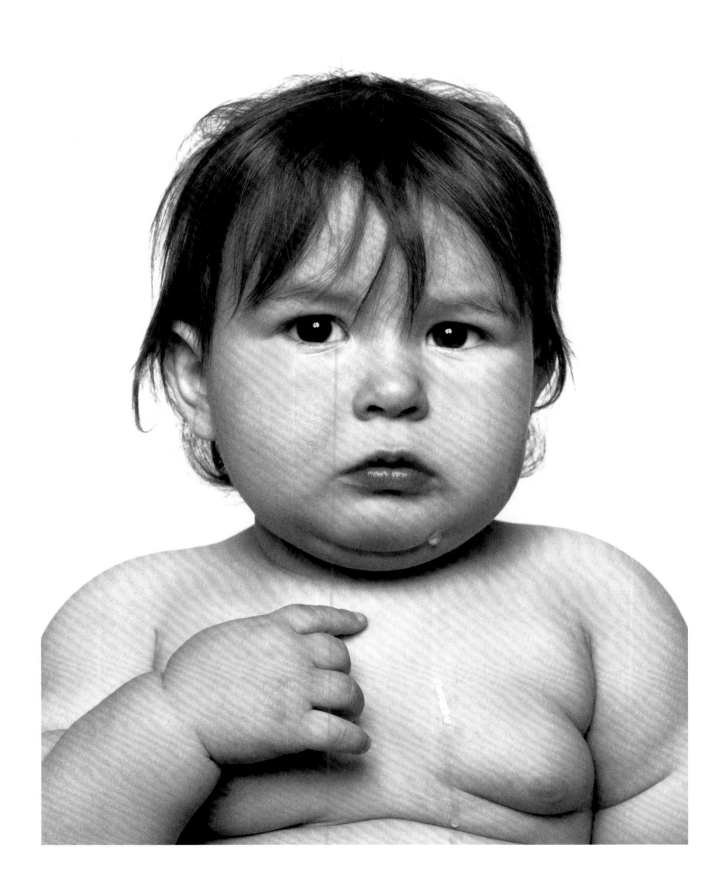

Wednesday, January 28, 2009; 4:52am

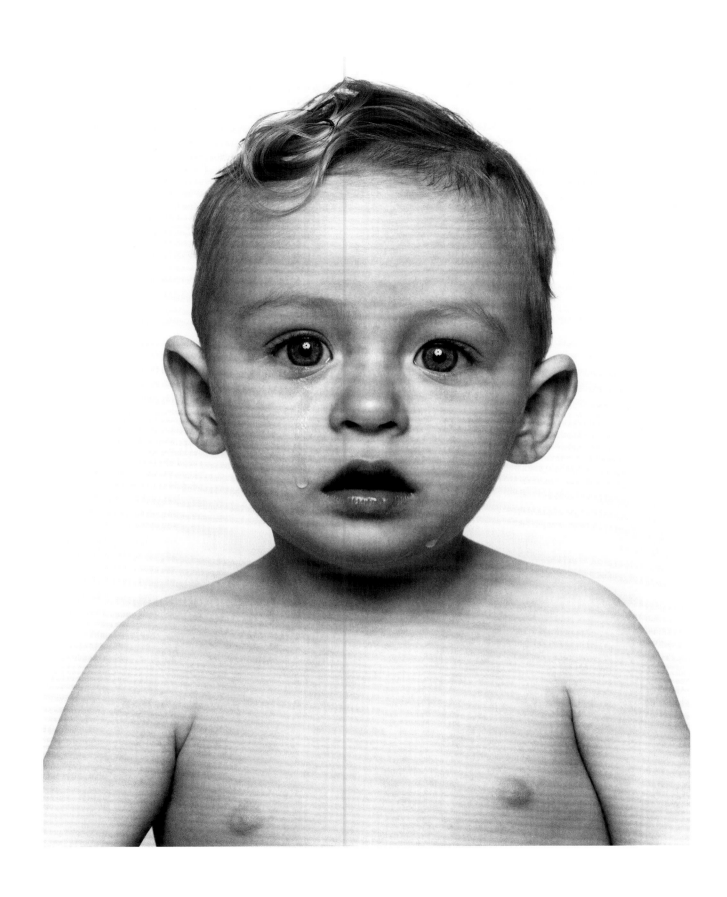

Saturday, May 24, 2008; 5:10am

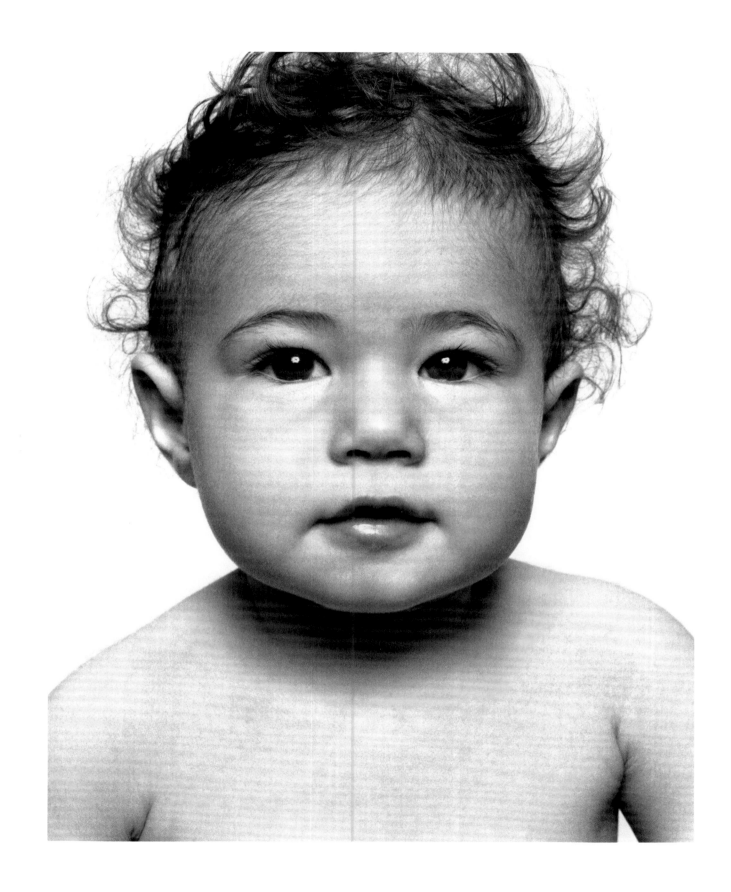

Sunday, February 28, 1999; 5:30pm

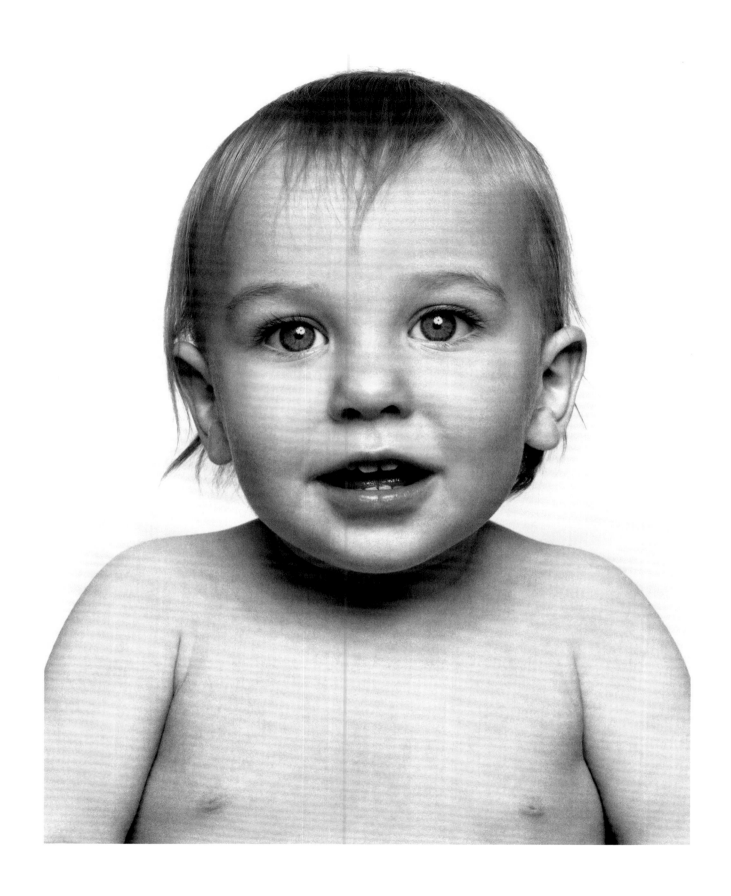

Sunday, April 20, 2014; 9:47am

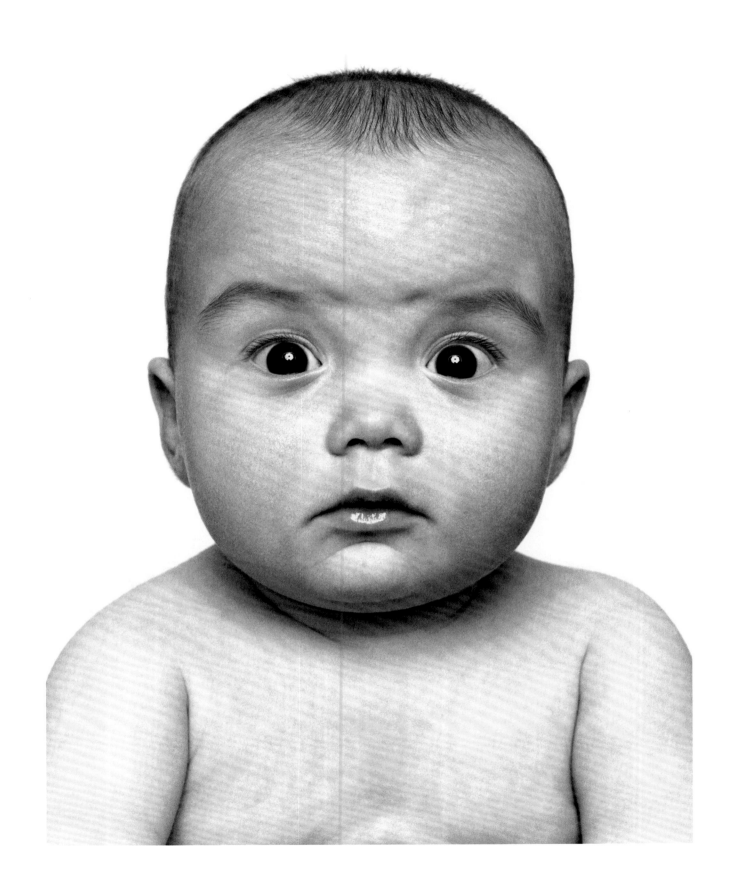

Wednesday, May 14, 2008; 4:56pm

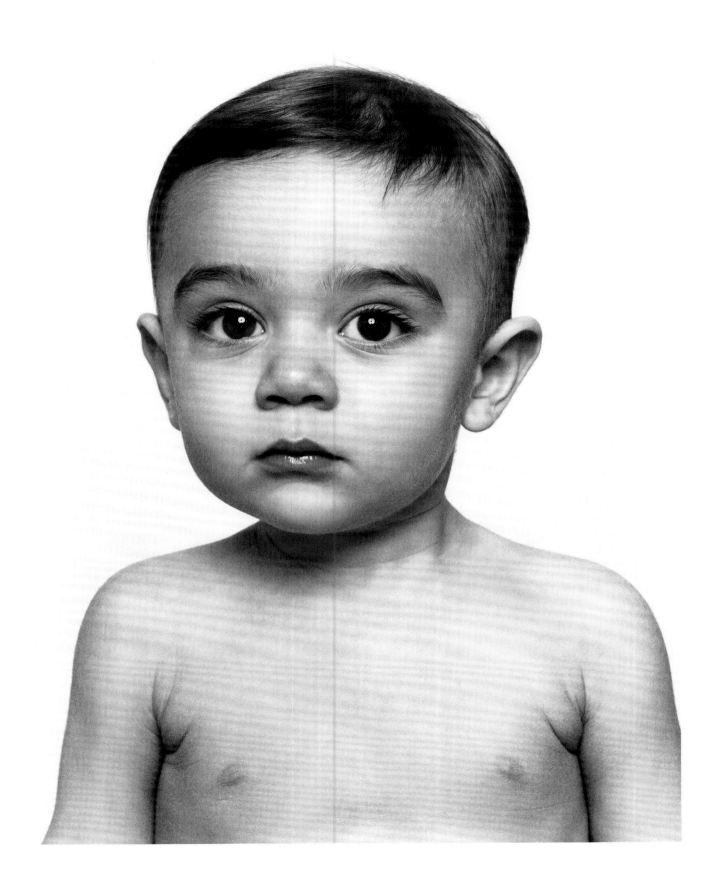

Thursday, April 27, 2006; 12:31am

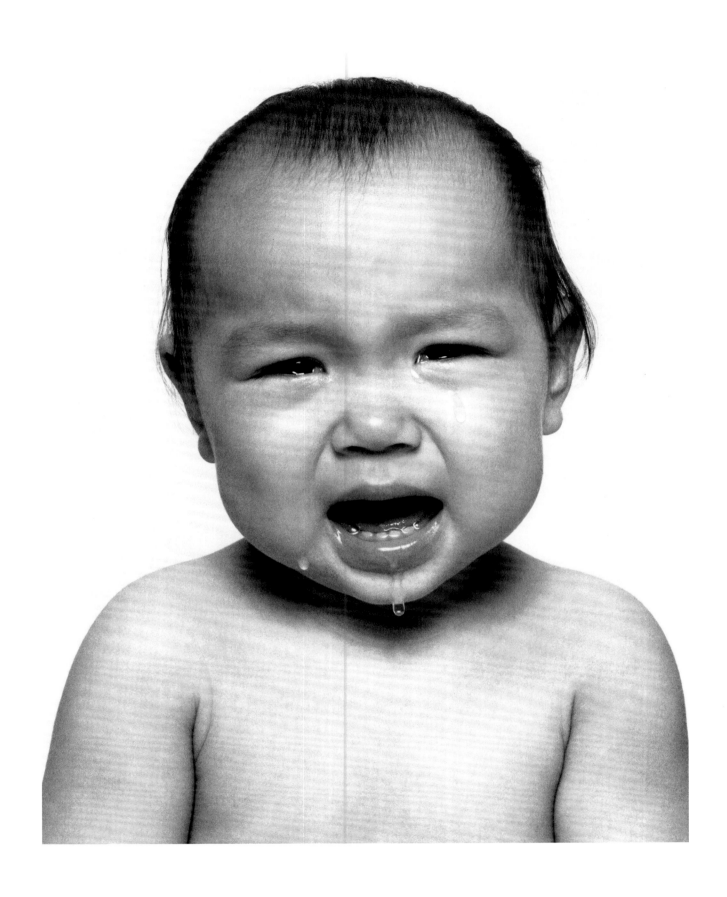

Tuesday, May 1, 2001; 11:48pm

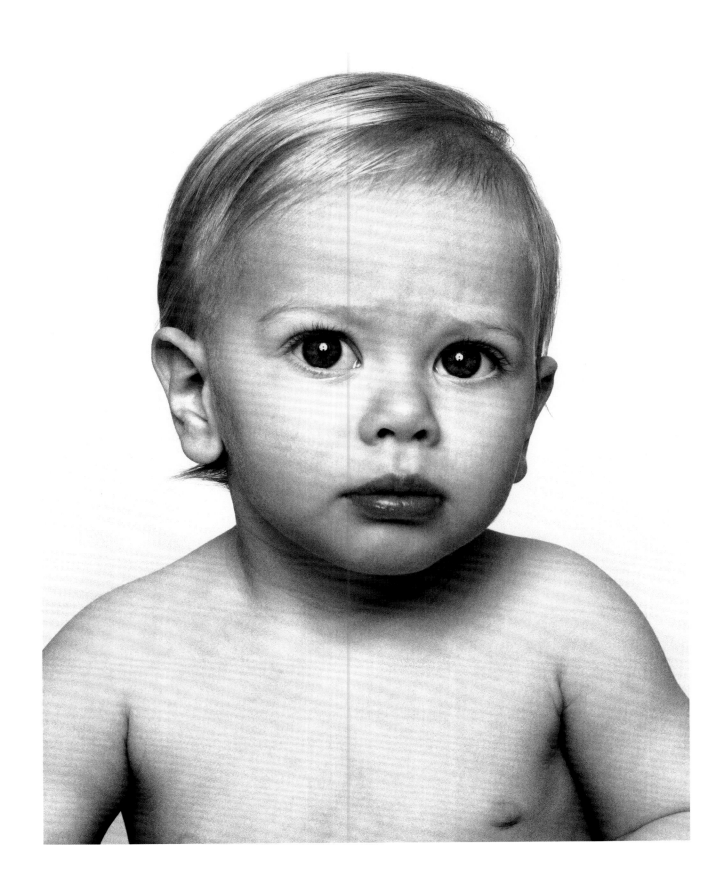

Monday, December 17, 2007; 7:31am

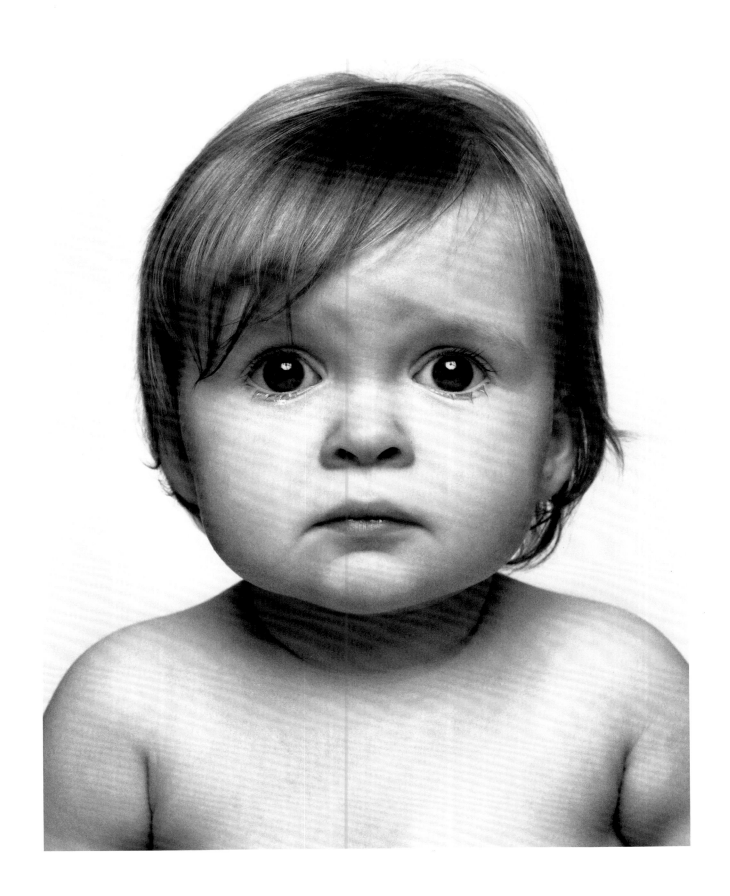

Tuesday, November 18, 2003; 8:21am

I would like to express my gratitude to the following for
their support throughout this book project:

Robert Ascroft, Samantha Boardman, M.D., Nick Bridges, Gregory Burnet, Craig Cohen and powerHouse Books,
James Danziger, Jonty Davies, Wes Del Val, Roberta Marroquin-Doria, Jay Dubiner,
Frederick Evans and Daniel Korkhov of Ludique, Sara Fitzmaurice, Michael Flutie, Ariel Garcia,
Adam Gopnik, Marianne Jacobsen, Dimitri Levas, Will Luckman, Miko McGinty, Patricia Morrisroe,
Taku Onada, Susan Orlean, Andi Ostrowe, Mary Gail Parr, Francine Prose,
Sergio Purtell and Black & White on White, Ira Resnick, Melanie Roberts, Steven Sebring, Patti Smith,
Andrew Solomon, Ruben and Isabel Toledo, Helen Tschudi, Jonathan Van Meter,
Jane Wesman and Jane Wesman Public Relations, and Andy Young.

I would also like to acknowledge the parents and guardians of all the children
I have photographed over the past twenty years.

And finally, a very special thank you to Michelle Mapplethorpe whose support never waivers.

— Edward Mapplethorpe

ONE: Sons & Daughters

Published in the United States by powerHouse Books, a division of powerHouse Cultural Entertainment, Inc.
37 Main Street, Brooklyn, NY 11201-1021 telephone 212.604.9074
e-mail: info@powerHouseBooks.com website: www.powerHouseBooks.com

First edition, 2016

Library of Congress Control Number: 2015959889
ISBN 978-1-57687-790-6

Creative Direction and Design by:

LUDIQUE

Printing and binding by EBS, Verona

10 9 8 7 6 5 4 3 2 1

Printed and bound in Italy